How to Teach Art?

Wiktoria Furrer, Carla Gabrí, Nastasia Louveau, Maria Ordóñez, and Artur Żmijewski

How to Teach Art?

DIAPHANES

Series **THINK ART** of the Institute for Critical Theory (ith)—
Zurich University of the Arts and the Centre for Arts and
Cultural Theory (ZKK)—University of Zurich

Funded by the Swiss National Science Foundation (SNSF)
and the University of Zurich (UZH).

1st edition
ISBN 978-3-0358-0436-2
© DIAPHANES Zurich 2022

Cover image: Artur Żmijewski, detail of the Theory
Development Sheet, collaborative notations made
on a large-format sheet of paper during the workshops
of *How to Teach Art*, courtesy of the artist and the
participants.

Layout: Maria Ordóñez
Printed in Germany

www.diaphanes.com

Contents

**Wiktoria Furrer, Carla Gabrí,
Nastasia Louveau, Maria Ordóñez**

Preface

You readers might be thinking: what a bold announcement to make—how to teach art! They'd better be convincing and know what a slippery terrain they're getting into. *How to Teach Art* was the title of a series of workshops by the Polish artist Artur Żmijewski that took place at the Zurich University of Fine Arts in spring and summer of 2018. The outcomes of the workshops were presented as a section of the exhibition *100 Ways of Thinking*, curated by Katharina Weikl and Daniel Baumann, at the Kunsthalle Zurich from August until November 2018.

As the practice of art-teaching is ever changing, it seemed necessary to us as authors to add a question mark to the title of this book to highlight the urgency to think about art education anew and anew. The epistemology of art itself, as we experienced it in the workshops, with its open-ended process, preliminary results, and iterative patterns, encouraged this approach. This book gathers both practical and theoretical insights produced during the workshops in the shape of reflections, artworks, and impressions. By doing so it aims to depict the specific methodology of the workshops, and its underlying pedagogy proposed by Artur Żmijewski, which stems from the didactic tradition of the Academy of Fine Arts in Warsaw as it was practiced by several generations of Polish art professors: Oskar Hansen, Jerzy Jarnuszkiewicz, Grzegorz Kowalski, and Wiktor Gutt together with their students.[1] This tradition is kept alive in the art practices of Artur Żmijewski and Paweł Althamer, as well as other Polish contemporary artists. As a student of professor Grzegorz Kowalski, Żmijewski was trained in using art as a medium of communication as well as means of social action: art is language and therefore able to decode the space around us and express things for which there is yet no language. While the pedagogy of Oskar Hansen, particularly in conjunction with his theory of the "Open Form," has been internationally received since its formation—first in architectural discourse, and in the recent years in contemporary art[2] —it is crucial to us to introduce the artistic developments of this pedagogy to a broader public beyond Poland for the first time.

And yes, we are that bold. The book does not just document this specific series of workshops: it is a manual presenting a hands-on method for facilitating artistic processes. The principles of this unique method are dialogue, collective and individual exercises, playfulness, confrontation with the self and with others, as well as fostering intuition.

The workshops were dedicated to the central question of how and whether art can be taught at all. We investigated the possibilities and conditions of teaching, learning, and even making art. "How to teach art?" was initially Artur Żmijewski's question.

To answer it he initiated a teaching experiment that inscribed itself in his practice of creating and igniting social situations.[3] The answer, however, turns out to be collective and polyphonic. The book gives account of this collective process of artistic investigation.

Based on Żmijewski's existential experience as an artist dealing with marginalized people, political violence, and vulnerable bodies, the workshops specifically raised questions about what is needed to keep an artistic process going under difficult circumstances. What is needed for an artist to remain vulnerable and receptive to the problems they want to tackle without being exposed to them in a destructive manner? This question resonated with the interests of a group of graduate and doctoral students from the PhD program Epistemologies of Aesthetic Practices, including Wiktoria Furrer, Carla Gabrí, Ekaterina Kurilova-Markarjan, Nastasia Louveau, Maria Ordóñez, Anja Nora Schulthess, Dimitrina Sevova, Nika Timashkova, and Valentina Zingg. Most of the participants were engaged in academic research in the field of art, and also pursued an artistic practice of their own.

The structure of the book follows the didactic structure of the workshops, which consisted of both individual and collective exercises in art practice. We worked with various media and were patiently trained by Żmijewski in several techniques: drawing, painting, collage, digital and analogue photography, video, and 16-mm film.

Żmijewski proposed a series of individual exercises that we realized in our own time and manner. The instructions for the exercise were formulated as a precise task, and demanded a response to a given material (for example photographs from historical newspapers) or situation (in public space or encounter with residents from a retirement home). In line with his artistic practice, which circulates around neglected topics of historical trauma, Żmijewski confronted us with photographic documents of the First and Second World Wars, the Warsaw Ghetto, colonial exploitation, 19th-century photographs of distorted bodies, thus tracing a history of violence.[4] Specific to the method of the workshops was the use of historic devices such as a 1910s Voigtländer plate camera and a 1960s Bolex 16-mm film camera. These devices were not innocent remains of past technologies; they were entangled in a colonial and war history that needed to be faced with an artistic strategy by each of us. The confrontation with these historical photographic documents and devices aimed at radicalizing the subjective position of each artist. Key to this subjective position was the notion of intuition—the ability of an artist to listen to and decode subtle signals, not received by other knowledge systems. In our imagination the artist functions like a highly sensitive radio receiver, detecting what is in the body, the earth, and the air. Art education is a way to regulate the sensitivity of the artist and to make them receptive to their specific "frequency." Thus becoming capable of channeling, transforming, and reflecting an artistic practice of their own. "What is in the body, the earth, and the air?" therefore became the final and unfulfilled exercise formulated collectively at the end of the workshops.

The individual exercises culminated in the task Study of the Human Body, where we filmed portraits of residents at the Alterszentrum Kluspark in Zurich—a task that demanded many of us to overcome a lot of inner resistance. The individual exercises sparked interests and practices that have continued well after the workshops ended. Some answers developed in the aftermath of the workshops can be found at the end of the book.

Collective exercises were group activities and the other main working mode in the workshops. In these sessions we came together and performed as a group, creating one big collective painting or sculpture or installation. The process of making was hereby more significant than the end result itself. We immersed into a playful artistic process, not focused on individual authors but on collective actions.

Collective practice was a new way to communicate for us as group: without words, only through gestures. Thus, during collective painting sessions, we knelt and moved around a huge sheet of paper rolled out on the floor. We would add strokes and signs to the paper, relating to the strokes and signs of the others. Every action provoked a reaction; gestures followed gestures. A visual dialogue emerged that followed its own rules and was highly intuitive. Collective exercises were executed with different media and objects. They were either randomly found in the spaces we occupied or were specifically brought along by Artur Żmijewski (see for instance works with wooden blocks on pp. 110–111).

In the Blackboard Conversations we gathered around a huge blackboard in the top-lit drawing room of the Zurich University of the Arts. We drew with chalk on the dark surface and pressed our bodies against it. In the back room we encountered skeletons for anatomical studies. Picking them out from the equipment for art students, we weren't sure whether we turned them into mute dialogue partners or if they invited themselves to the dance (see p. 86 sqq. and pp. 108–109).

The practical exercises were accompanied by group discussions. We explored questions and topics prompted by Żmijewski and the participants, shared concerns and doubts, and referred to theories and texts each of us was engaged with in our respective research. Besides aesthetic, art, and education theories, especially psychoanalysis—which Żmijewski was studying at the time—became a vital point of reference in our exchange.

Visual remains of these discussions can be found on the Theory Development Sheet (see image on pp. 100–101). This was a huge white surface consisting of six sheets of thick Japanese drawing paper taped together. During our discussions it was spread out on the floor and used as an oversized collective scratchpad gathering key words, questions, diagrams, and scribblings. It became a visual space for our discussions and a constantly reworked canvas for new ideas. Texts fragments and drawings were painted over and over again, like in a palimpsest, revealing the many, often contrary voices in the workshops. The sheet ignited our thinking through visual activities— this collective note-taking practice unleashed new thinking modes very different

from the dialectics of a rhetoric debate. Whereas in discussions somebody often has the final say, the Theory Development Sheet allowed for a simultaneity of conclusions and a co-existence of contradictory opinions.

Additionally, the discussions were continued in a closed Facebook group. These discussions reflected ad hoc what happened in the workshops, and are also included in this book. At that time, the Facebook group was a convenient way to collect the topics and interests through subjective summaries and to archive the works made by the participants. Today the written discussion script gives a vivid account of the intense debates during the workshops.

The book begins with a reflection by Artur Żmijewski and ends with reflections by Wiktoria Furrer, Carla Gabrí, Nastasia Louveau, and Maria Ordóñez. These texts shed light on the creative process from different perspectives. Żmijewski proposes a typology of artists and the metaphor of the alchemist as a model for describing the artistic process that both played a central role in the workshops. The other four authors carve out further notions. Furrer, Gabrí, Louveau, and Ordóñez develop new types and analyze the spaces and formats of the workshops through the lens of time. The workshops' themes and questions form the backdrop of a reflection that enters into a dialogue with the participants' own practices. This section unveils how the methodology gave space to the participants to develop their artistic practices and to follow their own interests.

How to Teach Art was only possible thanks to the engagement of many people and the cooperation of institutions. The workshops were organized as part of the doctoral program Epistemologies of Aesthetic Practices (Collegium Helveticum) in cooperation with the Centre for the Arts and Cultural Theory (Zentrum Künste und Kulturtheorie, ZKK), the ERC project *Performance Art in Eastern Europe*, and the SNSF project *Exhibiting Film: Challenges of Format*, at the University of Zurich (UZH), the UZH Department of Film Studies, the UZH Department of Slavonic Studies, and the Institute for Critical Theory (Institut für Theorie) at the Zurich University of the Arts (Zürcher Hochschule der Künste, ZHdK).

We want to thank Fabienne Liptay, Dorota Sajewska, and Sylvia Sasse, from the University of Zurich, and Dieter Mersch, from the Zurich University of the Arts, for making the workshops and publication possible. We also want to thank the coordinators of the PhD program *Epistemologies of Aesthetic Practices*, Benno Wirz and Katerina Krtilova, for their support during the workshops. We thank Silvia Henke, Fabienne Liptay, Dieter Mersch, Dorota Sajewska, and Sylvia Sasse as our doctoral supervisors for their support.

We are grateful for the financial support that we received for completing the book publication from the *Epistemologies of Aesthetic Practices* program, from the Swiss National Science Foundation, from the Graduiertenschule at the University of Zurich, from

the Lucerne University of Applied Sciences and Art, from the Swiss National Science Foundation, the Departments of Film Studies, and the Department of Slavonic Studies. Without your financial support, this publication would not have been possible.

Last but not least, we want to thank Artur Żmijewski for being our teacher.

Endnotes

1 See Jadwiga Jarnuszkiewicz, Wieslawa Wierzchowska, Piotr Szejnach (eds.), W kręgu Pracowni Jarnuszkiewicza. W 35-lecie pracy pedagogicznej profesora Jerzego Jarnuszkiewicza (Warsaw: Akademia Sztuk Pięknych w Warszawie 1985). (Catalogue accompanying an exhibition at the museum of the art academy in Warsaw in winter 1985, curated by Grzegorz Kowalski and Roman Woźniak.); Piotr Szejnach, "O Warsztatach Kowalni dla reszty swiata," in Grzegorz Kowalski (ed.), Kowalnia. 1985–2015 (Katowice: Akademia Sztuk Pięknych w Katowicach 2015), pp. 505–523; for Oskar Hansen see next footnote. | **2** See Aleksandra Kędziorek, Łukasz Ronduda (eds.), Oskar Hansen—Opening Modernism. On Open Form Architecture, Art and Didactics (Warsaw: Museum of Modern Art 2014); also Axel Wieder, Florian Zeyfang (eds.), Open Form: Space, Interaction, and the Tradition of Oskar Hansen (Berlin: Sternberg Press 2014); Jolanta Gola, Grzegorz Kowalski (eds.), Po 30 latach. Spojrzenie na pracownię Oskara Hansena. 30 years later. A look at Oskar Hansen's studio (Warsaw: Akademia Sztuk Pięknych w Warszawie 2013); Marcin Lachowski, Magdalena Linkowska, Zbigniew Sobczuk (eds.), Wobec Formy Otwartej Oskara Hansena. Idea – utopia – reinterpretacja (Lublin: Towarzystwo Naukowe KUL 2009). | **3** For Żmijewski's practice see Liptay/Sajewska/Sasse/Żmijewski (eds.), Kunst als Alibi (Zurich: Diaphanes, 2017). | **4** See the recent exhibition Miłe złego porządki (The pleasures of ordering evil) and its accompanying publication Artur Żmijewski, Miłe złego porządki (Kalisz: Galeria sztuki im. Jana Tarasina 2020).

Artur Żmijewski

How to Teach Art?[1]

During a several-month stay in Zurich in 2018, I conducted classes with a group of post-graduate students at ZHdK (Zurich University of the Arts). Our topic: how to teach art. The workshops were divided into a theoretical part and a practical part. We started with a typology of artists, not entirely serious, with an element of humor and irony. Yet it does seem useful to describe artist types and the creative processes characteristic of them. Very often an artist represents not one but a combination of several complementary types. I suppose that knowing an artist's place in the typology it would be easier to individualize the teaching process, to tailor it to a specific person and to their abilities. It might also be possible to determine the creative strategies of the individual; for example by examining the way a given person initiates their creative process and how they conclude it. That is, of course, if they even work in such a "sequential" manner—initiating the process and terminating it with the completion of a work of art. There are artists who persist in a state of vibration, their imagination always bubbling. There are also those who kind of "idle" between projects. We can say they constantly sustain a crawling creative process.

The typology of artists is an alternative to being able to define one's own talents—it is not to determine any kind of technical, manual, or other adroitness but to identify certain broader abilities that materialize in the use of film-making, painting or performance technique. For instance, it's about finding qualities like:

• I see "holes" or cracks in reality
• I know how to behave in and navigate a very complex social situation
• I know how to identify "blind spots" in social perception—and I know how to restore proper vision, at least momentarily.

Fig. 1 Photograph by Martin Gusinde, Three Shoort subaltern spirits, Selk'nam ceremony, 1923.
Fig. 2 Portrait photograph inspired by native South American body painting, taken with an old Voigtländer camera. Contrary to contemporary photographic technique, which strives to eliminate mistakes, we treated errors in things like exposure as beneficial. Here, proposal by Ekaterina for the face-mask exercise, see p. 135.

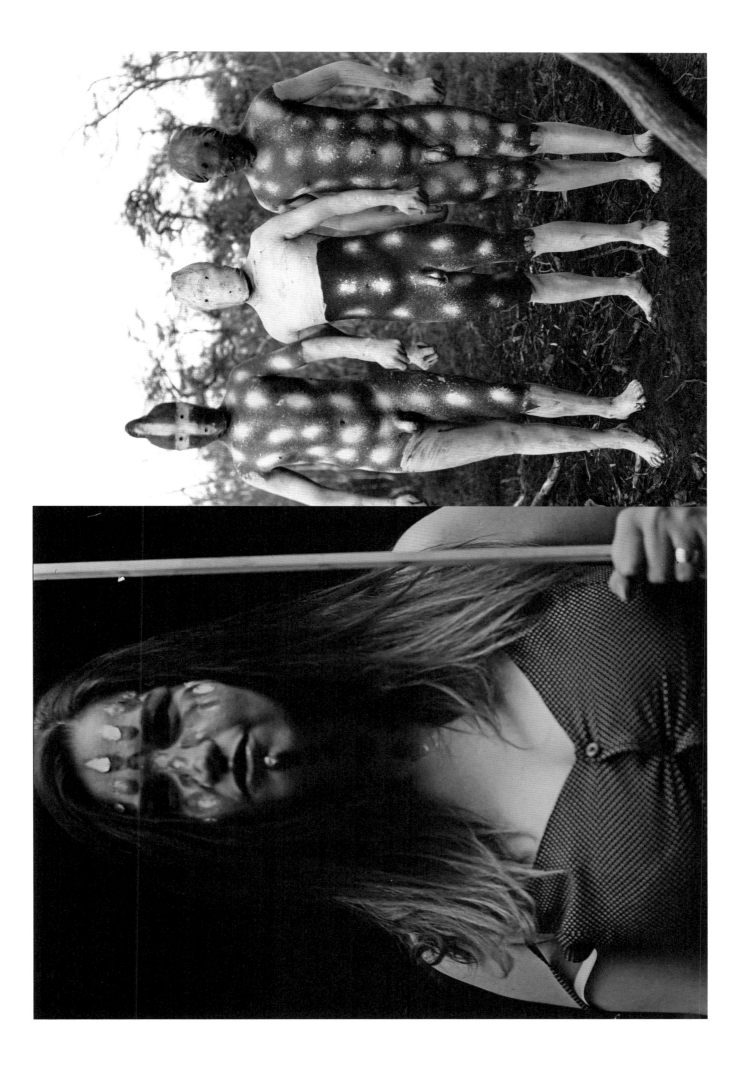

Typology of artists[2]

1. The Savant—in other words, an "idiot." This is not meant to be derogatory. It's about defining a type of artist who possesses one exceptional ability or skill. The "idiocy" which is the Savant's extraordinary gift often manifests itself in manual abilities. Like, for example, the ability to split a sheet of paper into separate sheets of half the thickness using only their fingers. In that single ability the Savant achieves outstanding effects—they paint, sculpt, film, or photograph in a manner impossible for others. They don't really know where that ability comes from—they cultivate it (painting every day), but it was there from the start, always extraordinary.

2. The Samara—the prototype for this type of artist is the character from the *Ring* horror films, in which a girl called Samara becomes a ghost. But before she becomes a ghost, she exhibits some unusual abilities. In some mysterious way she "etches" peculiar pictures on glass tiles. Asked by a psychiatrist if she makes the pictures, she answers, "I don't make them. I see them. Then they just are." I myself can say that I've experienced something like this, and I'm sure many other artists have too, having images or ideas simply "appear." What's left then is to bring those images or ideas to life with the right technique. This appearance of finished ideas, readymade concepts, or solutions "out of thin air" is what Marie Louise von Franz called "sudden ideas."[3]

3. The Calculator Man—this is undoubtedly one of those mixed artist types, occurring in tandem with another type like the Savant or Samara. The Calculator Man is a mathematical genius who can multiply long numbers in their head, doing it correctly every time. Interestingly, the answer does not always have to come instantly—the counting might take months—but it's always correct. The Calculator Man eats, works, plays, or despairs like anyone else—but in the "background" they're always calculating. Their mind and the calculation are always at work. After some time, the answer emerges. In the case of an artist qualifying as a Calculator Man, it is not about mathematics but rather questions of an existential, formal, or conceptual nature. This artist, however, when asked to solve a difficult problem will generate an answer, carrying on normally but "calculating" in the background. Eventually they will provide the right answer.

4. The Lifestyle Hunter—a non-artist, but quite indistinguishable from an artist. Enamored of a certain imagined lifestyle, they yearn to be an artist. Yet their art is an imitation of art—it has many of the formal qualities, including the tricky ones, and it essentially tastes and smells like art, though it isn't art. The Lifestyle Hunter will seek affirmation of their aspirations by going to open calls, making pitches, or producing art at their own peril, doing the proverbial "own thing." If they knew how excruciating the work of an artist is, they would seek fulfillment elsewhere.

5. The Artisan—a heroic figure, usually a tremendously skilled individual (perhaps simultaneously a Savant, blessed with innate manual dexterity, but also having pa-

tience, etc.) who has not taken the plunge to make their own art. Possessing first-rate reproductive and technical abilities, they offer their services to other artists. Such individuals work, for example, for companies in the town of Carrara, where they sculpt the ideas of iconic art-world figures into marble on the basis of supplied models.

6. The Functionary—often this is an artist/activist who is kind-hearted to a fault, who has decided to turn their art into a form of aid to others. In their artistic practice they organize after-school programs, teach languages, offer workshops, help create public space to improve people's lives and to include the excluded. The Functionary's activity may come in a variety of forms—usually the effects of their work are beneficial; the city is friendlier and people feel better. It seems, however, that this type of artist is burdened by a certain servility, in which satisfaction hinges on approval from beyond just the art world and the media covering it. I myself have walked in the shoes of the Functionary many a time, running workshops for prison inmates, children or people excluded in one way or another—for example, for Polish migrants in Ireland. The widespread approval supplied a great deal of gratification in exchange for the effort put into the workshops or meetings. Today, however, I am possessed by the Gombrowicz-esque conviction that art is meant to explore impasses and not to level the playing field. I eagerly get involved, but I don't necessarily use art for that— here a radical separation creeps in. A version of the Functionary that is interesting and dear to me is Harvey Keitel's character Mr. Wolf in the film *Pulp Fiction*. When the brain of a shooting victim splatters all over the interior of the criminals' car, it is Mr. Wolf, the professional "problem-solver," who comes to the aid of his crime-syndicate cohorts. He instructs them to wash the car's interior with water and cover the seats with old blankets, after which he will take the car to the scrap yard. To me this is a good metaphor illustrating the pathways of the artistic imagination and aims formulated for art dedicated to helping.

7. The Junkie—a person addicted to reliving the creative process. They constantly reinitiate the process, treating it as the only satisfactory means of existence. The classic studio artist who locks themselves away in the studio, where they have their own "banana republic." The quality of the art produced is not of primary importance.

8. The Desperado—an artist whose goal is to generate a reaction in others, in the viewer, media, etc. They constantly ask others, "Who are you?" This type tends to be enshrouded in ambivalence, which boils down to a hysterical demand to "Tell me who I am!" This type of artist creates scandal and makes art that agitates. Yet often, instead of getting the coveted answer, they encounter societal blowback as a response to their questions.

9. The Shaman or Shaman-being—a sorcerer in contact with the spirit world, a "medicine man." Someone who does odd things, who lives esoterically, driven by impulses, blessed with all-seeingness. A "divine madman" living on the fringes of society who is often asked for various kinds of artistic intervention and assistance.

Fig. 3 Collaborative notations made on a large-format sheet of paper—they concern the discussions on artist types, on the potential (or lack thereof) to control the creative process, etc. The exercise of sketching the theory was an attempt to capture it in visible and material form.

16

A variation of the Shaman is a Shaman-being artist whose life blurs the boundaries between creativity and everyday existence, the two blending into a uniform amalgam in which inspiration flows bilaterally.

What connects most of the above types is a lack of control over the creative process. Something appears or is revealed to them; they have visions, ideas or concepts—yet where these come from, they don't really know.

In Jakub Banasiak's wonderfully interesting interview with Julian Jakub Ziółkowski on the latter's time in Vietnam, titled "Nachapacze i Apacze" (*Szum*, 15 May 2018), the well-known painter describes his creative process like this: "Imagine you have something inside you. You don't know what it is or where it lives but you know it's there because you hear it calling. It follows you everywhere and calls you louder and louder. You want to release it but you don't know how, you don't have the key. You have to get to know yourself well and perform a kind of magic feat of opening yourself up to be able to get at it. Then, when you finally let it out, you don't actually know what has happened or how." Ziółkowski correctly states later on in the interview that you can't teach painting … because how can you teach someone to "let out who-knows-what in a who-knows-how way?"

Despite saying this, Ziółkowski knows how to create the conditions for his creative process that allow him to paint, and to do so successfully. He senses, knows, that there exists a situation in which all of the coordinates of the creative process function harmoniously toward the production of an artwork. He describes it this way: "The painting I am about to make is already there, in me; it *is* me. The studio is just where it comes to life. I call it synchronization." Ziółkowski, who in the proposed typology would fall under the Samara ("I don't make them [images]. I see them. Then they just are") and the Savant (exceptional manual and coloristic proficiency), seems to suffer from a lack of control over the creative process. He senses that for it to begin something special must occur. That's the synchronization he mentions. Looking at some excerpts from the interview, it is possible to identify several components of this synchronization:

- Spatial deprivation ("I love studios like this one, with roof windows, because no-one can see me here, which makes me feel safe. The more secluded a studio is, the more cut off from the world, the better my contact with myself.")
- Social and geographical deprivation ("And, I went abroad, as it turned out, for eight months. I rented in house in a part of Hanoi, a very local area far away from other foreigners and even farther away from the art world. My closest friend was a motorcycle, actually a scooter, on which I would ride around day and night through the huge city in unimaginable solitude.")
- Standing on the edge of life and on the verge of depression, looking into the existential abyss, mortifying oneself ("I worked all day long there, in those very modest conditions. The people there live practically on the verge of destitution. […] Late in the evening I would come back to the real world, looking at the nocturnal face of the same long street full of prostitutes sitting in these tiny rooms made of sheet

metal and tarpaulin all along the road. It was a horrifying picture, because often they were poor girls from distant villages. It breaks your heart and after that it's hard to get back into working. That's more or less how I spent my time—working and eating what the lady of the house had prepared: pork skin, hearts, intestines …")

Jakub Julian Ziółkowski returned from Vietnam a changed man. Toward the end of the interview we learn that, although he still follows his intuition, he has managed to alter his working method—he married fellow artist Hyon Gyon, and now they work together; there is far less "who-knows-what coming out who-knows-how." Today painting no longer brings pain and irritation ("I was burnt out. I couldn't bear the sound of a paint brush on canvas anymore"), and the creative process itself becomes controllable ("Hyon runs around the studio with a gas burner and breathes fire, and I stand by with a fire extinguisher"). It's striking how Ziółkowski's words to Banasiak start to sound like alchemical writings—vague, metaphoric, foggy, but emanating a certain beauty—despite attempting to provide a recipe for "how to make art," they are utterly impossible to put into use that way. You can meditate on this interview, really get inside it, but it never turns into a formula for making a good painting, – even though, in the deepest sense, it is just that—a very precisely outlined recipe for art.

So, accepting that art—like poetry—is dictated by a daimonion, it is useful to know how to create the right conditions to hear its whispers. And in this way we come to nearly the last type of artist in the typology: the Alchemist. They differ from the others in that they know how to control the creative process.

10. The Alchemist—an artist who can initiate the creative process, can control its course, and can terminate it when the time comes. The Alchemist artist's creative process can be divided into phases following the metaphor of the alchemical process and its subdivision into three primary steps:

I. *nigredo* (black/wet/shapeless)
II. *rubedo* (red/hot/taking shape)
III. *albedo* (white/dry/shaped)

The outcome of the process is a work equivalent to an alchemical formula that can transmute ordinary metal into gold—a work that can change ordinary people into ones capable of reflection. The work can make an impact on the human realm: trigger emotions, evoke connotations, compound ambivalence, and influence social processes. The Alchemist artist is oriented not only to matter; they themselves are the matter undergoing transformation, and the *materia prima* defines their psychological makeup, character, and interaction with the world. In undergoing the process of "heating" they mature and change along with the work itself. The Alchemist artist may not know what exactly transpires during the creative process, but they know/feel that they are subject to the process's influence; that their body and emotions are part of it—as material components of the process.

11. An interesting type that arose during discussions with the students is the truly final one in the typology, whom we called the "Carla." Carla was a real participant in the talks and workshops. In one instance she vehemently opposed the types proposed, arguing that we were concentrating excessively on a "medicalized," pathologizing typology and not enough on personal experience. She thus went on to tell us about her own creative strategy. When we understood that this was indeed a description of another creative type, we included it in the typology under the name of Carla—yet this is an abstract "Carla" and not the artist we had all come to know. What was interesting in Carla's strategy was the existence of a game between controlling and not controlling the creative process. The artist always starts by rationally defining the problem or topic. They decide on a medium and materials to create the piece and on the time it would require. But then they "lock themselves" a certain distance away from the social world and experiment with their chosen visual substance, orchestrating it in various configurations.

This part of the process is repeatable, and Carla can initiate the phase at any moment. Experimentation with the visual substance did not induce boredom in her—she could obsessively return to various configurations and transform them again. This active phase is a wait for something to happen—for what she calls a "surprise"—a configuration of the visual substance that jibes with her inner definition of what the work ought to be. Essentially this is a phase in which Carla shuts down rational thinking to activate and submit to her intuition. She is able to create working conditions conducive to intuition that dominate the creative process and present a solution to the artistic problem. For her the intuitive stage is the most intense and interesting one. Nevertheless, it comes at a cost: when the solution, i.e., the finished piece, arises, Carla loses all interest in it. It becomes something of a side effect of the process itself, of which the primary objective is to experience the state of suspended rationality and logic. Carla uses rational actions to achieve the effect of temporary rationality shutdown.

The type exemplified by Carla, however, did not provide an answer to her actual question on "how to be a badass good artist." The ability to initiate the creative process is obviously not enough. There is something else that makes an artist's work "badass." But let us ignore critical response and how accolades fall on the work of this or that artist. Let us focus instead on the mechanisms of the choices made by the artist themselves.

Proposed during our discussions was Lacan's model of the way content emerges. Let us assume that in the collective and individual unconscious there is something like a constant circulation of rhetorical elements at play. These could be words, symbols, phraseological units, etc. They can also be more complicated units containing certain content or knowledge. From time to time, when the conditions are right (like at the moment of "synchronization" described by Ziółkowski), the rhetorical elements bounce into the conscious plane—they emerge from the chaos and create content. In this event the content arising may have the form of a work of art, for example.

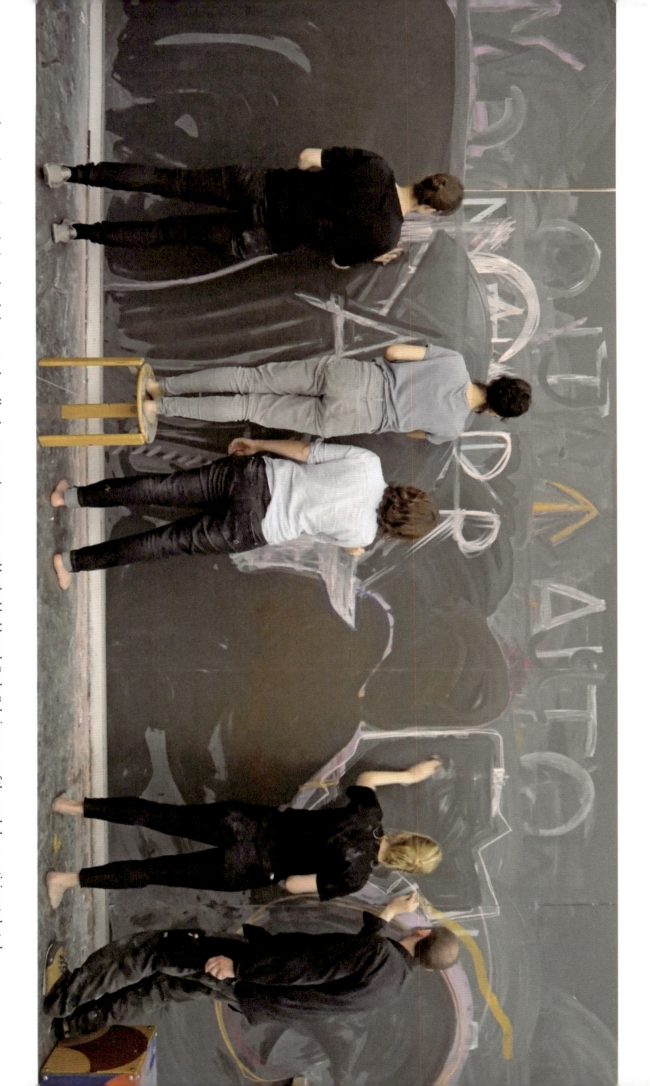

Fig. 4 The question "Who is Carla?" being put to the collective unconscious represented by the blackboard. Carla Gabri was one of the workshop participants but also an entry in our artist typology. Carla organized her working conditions so as to be able to turn off rationality. Interesting in her strategy was the coming and going of control over the creative process.

It's not just for show that Ziółkowski and other artists need social isolation and silence to "hear" or "see" the emerging—and hitherto invisible—rhetorical elements. It is under such circumstances that a sensible whole takes form in their consciousness, with them being the medium for that formative work. Lacan's model also adequately reflects the impression that there is "something in the air" at play. Perhaps the rhetorical elements coalesce into units whose content is supplied by the mass thought circulating around a given subject. Their concentration and density radiates, as if demanding to be heard or seen. The artist may be that individuum who, via the practice of social deprivation, of sequestering oneself in solitude and silence, is particularly prone to observations and impressions that are inaccessible to others. Maybe that is the proverbial "nose" for art (or politics). For the purpose of our discussions we embraced the metaphor of "radio waves," which penetrate and diffuse through the human reality carrying weighty content. Yet a sensitive receiver (artist) is needed to pick up a given frequency.

To cover the bases we convened twice for collective exercise sessions aimed at finding answers to the questions posed to the collective unconscious. Representing the collective unconscious was a large blackboard measuring 8 × 3 m. Participants could freely draw, write, erase, or change the form of all of the input. On it, we would write one question: for example, "Who is Carla?" or "What is the origin of the paintings made by the Samara?" (one of the artist types). We arrived at something like an answer each time. These answers were mostly of a performative nature, or a dialogue of sketches full of emerging meanings. In one instance we had an answer that was condensed into a single word. Arising as the answer to the question "What is the origin of the paintings made by the Samara?" was the word "Time."

The problem, however, lies in reading, or rather decoding, the content emerging from the rhetorical chaos. How broad is the band that an individual artist can decipher? Is it not that one of the difficulties faced by any artist is the shrinkage of the band being read, hence a shrinkage of the content itself? The same forms over and over, just in different configurations and colors. Sometimes the key contents structuring the lives of a given community are obvious, visible. But sometimes they lie hidden, acting like radiation does—without a taste or smell, making no sound, invisible to the eye. Just the same, they can trigger human misdeeds and change the fate of the community. These digressions also spawned another subject of inquiry: "What is in the air, in the earth, in the body?" It seemed to us that this is a question constantly posed to artists. If the artist knows how to answer this question, if, penetrated by the invisible radiation, they can decipher it, then for a few moments they are a badass artist.

But how do you teach that? How do you teach seeing something that isn't felt, heard, seen, or tasted? We arrived at the conclusion that what you can do is to teach how to create conditions that are conducive to intuitive work. For a given individual, it is possible to define a set of practices that can enable them to read things that are unseen, unfelt, and unheard. And this is not about work in the studio, where it's "quiet, empty and dim." It is possible to describe the artist's work with the metaphor

of the alchemist's work—with its stages and its ailments. With depression, illness, and strange emotions—with all that comes from outside as an element of the creative process and not of the artist's self. It is therefore important to be able to separate that which comes from the process from that which is an integral component of the self. It's important to keep your nerve and not get flustered. If you are working with refugees, seeing the misery of their lot in life, it is easy to fall into grief and anger. What must be remembered is that both grief and anger are part of the process and not part of our own personal reaction. As cynical as it sounds, this is an important element of self-knowledge and of survival strategy. What comes from the process is just as real as what comes from one's own feelings.

What's at stake is survival. The artist has finite resources and limited resilience. The protective barrier they deploy will wear down and eventually regenerate, but part of it will be lost irreversibly. So what if one runs out of resilience? What if one is overwhelmed by the emotions absorbed from outside and uses up all of one's resources for restoring the soul's balance? What comes with the process must leave with its conclusion. What wears on the artist's immunity barrier must subside when the process comes to an end. But what if it's necessary to maintain one's defenses even once the work has been created; when the artist is confronted with the opinions of disapproving onlookers who band together against the work and the artist himself? Then the cracks in the immunity barrier will grow. Resources can run dry and the immunity barrier can crumble. The sensible thing, therefore, is to teach students how to use their resources wisely.

Which leads to the following question:

How do you listen to your intuition; how do you follow the whispers of the *daimonion*? Sometimes it's quiet enough for the whispers to be heard. But what about when the artist is surrounded by a crowd, or working in an area of conflict, when things are much more unfocussed than in the isolated studio? How does the artist activate intuitive work and hear the whispers of the *daimonion* then? How do they bring the "elements of rhetorical circulation" to a level that is visible and audible to them? Or, conversely, how do they peer into the space in which they circulate? There arises the metaphor of a psychotic episode triggered by an overload of unconscious content. If you provoke such an overload and it takes place, then how do you lucidly process the unconscious content and not fall into mental illness?

We came to the conclusion that some of these questions are technical matters, and that the example of Carla shows it is possible to formulate instructions for activating intuition "on demand." There is, however, one caveat: Carla said nothing about emotions, which are part of the process initiated by the alchemist artist. And it is possible to teach someone to be open to emotions, to initiate as well as terminate the creative process itself, and to differentiate what comes from the process and what comes from within.

Before wrapping up, let us take a telegraphically condensed look at some problems that arose during the course of our discussions and were not explored further. The

Fig. 5 A portrait photo taken by Wiktoria Furrer as a test of an old Voigtländer camera from the early 20th century. We wanted to take pictures with the camera, hoping to obtain a certain "deformation" of the images coming out from the camera—from the human subjectivity encoded by it. The test showed that the Voigtländer picture is very different from that of modern digital cameras, whose construction results from a need to objectively reproduce the world around us.

truth is that when you start to speak you quickly discover how much more there is to say. And when you start to do, you realize there is much more to be done. We ourselves happened to go the latter route—into doing: drawing, filming, photographing. Theory fell by the wayside, replaced by moving and still images, encounters with the people we filmed, and observation of the beautiful city in the valley which served as the backdrop for our explorations.

Here is a list:
1. Freud wrote that psychotherapists and psychologists working with people observe, and perhaps even know, the contents of their most deeply concealed psychological processes. It is these processes that are the substance of their work with people—they are the place where the fundamental choices concerning life, fate, and the future take place. We discussed the story of a young doctor who specialised in forensic medicine. Though her job often sent her into depression, she was

obsessively attached to her work. She sought help from a psychologist, who asked about her family. It came out that the doctor's father had for years been engaging in a dubious practice—every evening he would lie naked on the floor for hours. Asked to investigate the reasons behind her father's conduct, the doctor got her father to reveal a secret he had been hiding his whole life. He had been a member of a *Sonder-kommando* in a Nazi death camp, forced to clean the crematoria and burn the bodies of the murdered. It then became clear why he repeated his strange performance each evening—it was essentially a way to theatricalize his memories. It also began to make sense why the doctor had chosen a specialization so evidently ill-suited for her. What did not become clear was why, having no knowledge of her father's past, she chose to "follow in her father's footsteps" and start doing something similar to what he had done. She must have been a victim of radiation; the horror of her father's life experience infiltrated her deepest psychological processes. When she dug down into these processes, she discovered insight and was able to change her life. She changed specializations and went into pediatrics. Couldn't this also be a good story about an artist? On the surface an artist seems to live a normal life, but their deepest psychological processes are infected by the poisons produced by individuals and by groups—that infection is the artist's lifeblood, their means of cognition. In their own deepest psychological processes they seek the substance of art, brought there by radiation and waiting to be "utilized." That is the location of all the hidden paths taken by society and the individuals at their mercy. Just like it was something latent that forced the doctor to make an undesired choice, it is something latent that manifests itself in the deepest psychological reality of the artist. If the artist can reach that, they will obtain substance for their art. Many symptoms that appear in the bodies of individuals, or manifest in the psyche, can come from a "non-own" process (as the case of the doctor and her father)—a process in an individual or a group. They can also come from political processes. These symptoms are our brutal companions—becoming one with them can teach us a lot. This is what we mean when we say, "hidden in the air, in the earth, in the body."

2. The task of art teachers is to foster this "sensitivity" in the students so that they are able to see the invisible, hear the inaudible, and touch the immaterial. So that they can understand their own symptoms as ones that come from a "non-own" process or processes.

3. There was a discussion on artists' sensitivity in which the analogy of a radio receiver was made. Certain frequencies are strong and easily picked up, but others are weak and the receiver's sensitivity must be increased to tune in and listen. There are

Fig. 6 Frames from a film by Maria Ordóñez on the theme of "study of the elderly body." The assignment was to make a short 16-mm film as essentially a nude study. Taking part in the exercise were residents of a seniors' home located on Klusplatz in Zurich. Wiktoria, Maria, and Carla took various footage of one of the residents, a one-hundred-year-old man. The subject of the film passed away only a few months later, and the footage taken then turned out to be the final trace of the man's life. The filming process was a profound existential experience for the artists, and the man's death only deepened the feeling. After all, in some way they were part of the man's "final path."

transmissions that no one hears, so the way to hear them would be to dial up the sensitivity of the receiver somehow. Given as an example were certain places in France that witnessed particularly intense carnage during World War I. What if the remains of the casualties buried in the ground there are still emitting their pain? What if the soil transmits the voices of the dead whose bones it conceals? Our task as artists would be to turn up the receiver's sensitivity and to amplify the volume.

Thank you for your attention.

The workshops were organized as part of a PhD program co-organized and funded by the Collegium Helveticum, Zurich University of the Arts, University of Zurich, ETH Zurich, and led by Fabienne Liptay, Dieter Mersch, Dorota Sajewska, and Sylvia Sasse.

Endnotes

1 Text first published in Postmedium 1–2, Poznań 2019, ed. Adam Mazur and Tytus Szabelski, pp. 31–45; with their kind permission; translated for the present edition by Szymon Włoch. | 2 The attentive readers will notice contradictions between the different versions of the typology (here and the following Summary of the 1st Meeting). Since this typology emerged out of discussions, its written form kept evolving along the process, which explains the contradicting numbers. | 3 See von Marie Louise Franz, Fraser Boa, The Way of the Dream: Conversations on Jungian Dream Interpretation with Marie-Louise von Franz (Boston, London: Shambhala 1994), p. 11.

Typology of Artists—Summary of the 1st Meeting

Dear All,

We have had three days of presentations and discussion. Thank you for presenting what you are interested in and what you do / are busy with / focused on. I'd like to sum up what we were talking about until now (please feel free to discuss, present doubts and different opinions). The final conclusion of our collective work could be a presentation which shows the internal polemic of opinions and philosophical positions—also practical positions:

A Typology of artists
1. Savant ("idiot"—equipped with one unique skill)
2. Samara ("I don't make them [images], I see them then they just are"—as one of the main characters of the movie *The Ring* said)
3. Calculator Man / Woman (subconsciously calculates in mind / produces answers)
4. Lifestyle Researcher (such a person understands art as a specific lifestyle and tries to join the group of professional artists to celebrate their imagined lifestyle; produces simulation of art instead of art)
5. Functionary (a kind of social worker/activist who reduces art to people's support; the good but somehow "inverted" example is Mr. Wolf from the movie *Pulp Fiction* who solves problems of the others)
6. Artisan (rather craftsman than artist; quite often offers professionals artistic service)
7. Politician (equipped with a "political mind"; not really trained at art schools)

Positions 1–7 represent artist types who "do not control" the creative process;

8. Shaman (not discussed yet)
9. Alchemist (person who is able to activate creative process consciously and also terminate the process; process itself is divided into phases; emotions are included; following alchemical metaphor there are 3 parts of the process: *nigredo*, *rubedo*, *albedo* [black/wet, red/hot, white/dry]); finally we have an artwork produced which is an equivalent of magic alchemical formula able to transform ordinary metal into gold; in this case our formula/artwork is able to transform human world: activates emotions, thoughts, creates controversies, transforms social processes, and so on; the alchemist is not only focused on material itself but also on his/her own self development; the process itself is a transformation of "materia prima" into organized forms, but also transformation of the artist as individual who needs to "grow", "become mature"

Position 9 (and probably 8) represent a type of artist who is able to control the creative process—being open to intuition or irrationality and who swims well in the ocean of individual and collective subconsciousness.

B. How to teach art?
1. Art can be understood as a visual, "non-verbal" language with its own grammar and vocabulary; it's unclear if it's possible to teach artists (transform ordinary person into artist through the education process), but it's possible to teach craft (as a craftsman I know how to use visual language);

2. Creative process is not reduced to specific use of visual language—it's something much more complex—that's why the metaphor of the alchemist was proposed; alchemist could know the grammar of visual language but should remember about emotions involved in creative process; should know how to follow even very subtle prompts and hints; should know how to deal with strong emotions that come from the process itself; should be aware the process can be initiated by him or her but also other people can initiate it and "force" artist to find an answer;

3. Artist can know the problem/question/request but artist can be also exposed to not asked / not formulated questions / requests—or can be confronted with questions which are very unclear or even dangerous. Good example comes from the movie *Marathon Man*, in which Dustin Hoffman is confronted with the very strange question "Is it safe?" He would like to answer but he doesn't know the context of the question; he is even tortured by the people who ask him this question. This is a quite typical situation of the artist: he/she knows the duty (to make high-quality art), but doesn't know which problem should be elaborated by such an art; this situation is a torture. In my opinion this is how artists are educated nowadays—students are confronted with social wish to make good art, but they do not know exact problems they should discuss and do not "speak" the visual language fluently. They jump into a chaos of problems and forms. Using the proposed terminology, one can say they do not control the creative process (to formulate or to hear the request is a part of creative process).

C. Temporary conclusion (to be discussed)
The discussion was intense (for example emotions were problematic or the possible use of proposed typology of artists) and productive. What could be continued is a research focused on control / awareness of the creative process / self-awareness.

Please feel free to react, comment, and discuss.

Artur

I. SAVANT [IDIOT]

II. SAMARA ["THE RING" / I DREAM ABOU

III. CALCULATOR MAN
WOMAN.

IV. FUNCTIONARY ⟹

V. LIFE STYLE RESEAR
TYPICAL

VI. ARTISAN [less then
but ...

VII. POLITICIAN POLITICAL
IMAGINATION

VIII A DESPERADO — COGNITIV

VIII SHAMAN ACTING BEUYS, A
VIIIa (limits) MAO MEN (NC) — ex
VIIIb. JUNKIE — OCD

X) ALCHEMIST |||

(?) MOSES

Artur Żmijewski

Deny and Confirm the Image—Individual Exercise #1

Using abstract forms and maximum five colors (white, black, grey, red, and blue) deny and confirm the images

Participants received images taken from two books: about the Warsaw Ghetto and about medical photography focused on pathological changes of the human body. The idea of the exercise was to focus participants on certain "unpleasant," dark sides of life and give them a limited number of tools to confirm something that cannot be "confirmed" and to deny something what can not be "denied"—it's impossible to deny or confirm Nazi atrocities or deny illness. But that's exactly a space in which art operates—a kind of liminal space in which artists need to find a way of expression of the "impossible."

Participants were also allowed to test if they control their own creative process or— even in such strongly defined conditions—they are not able to control it.

Fig. 7 Theory Development Sheet, detail in black and white.

Fig. 8 Photograph from the archives of La Salpêtrière, first photographic documentation in the field of clinical psychiatry, 19th century.

Fig. 9 Photograph from the Jewish ghetto in Warsaw during Nazi occupation.

Fig. 10 Proposal by Carla Gabri: affirm the image over and over again until it finally starts to disappear.

Extension of the Typology of Artists—(Subjective) Summary

Carla Gabrí
May 3, 2018

Dear All,

I have two concerns that I want to share with you.

The first concerns my ever-present resentment against the typology of artists. You are absolutely right; it served our discussion, or at least started the discussion about the process of artmaking. We mapped out different tendencies of art-making, and consequently we were able to relate to them. But for me this profit comes at a price. Which is that we reduce complex behavior, personalities, and circumstances to artificial punchlines. Rather than describing our individual art-making processes (or more generally speaking the way we create creative output), which is ALWAYS changing and growing in relation to the task we are confronted with, we follow a top-down deductive process that is in itself static, reductive, and also incredibly negative—I cannot think of a single type on our list that doesn't sound negative in one way or another (apart from the Alchemist, of course, but you cannot tell me that this is the only way to produce "real" art).

So my question is, WHY do we have to map out something that is so artificial and in the end even harmful? It glorifies these 1–5% of so-called "real artists" that find their enlightenment way into the sun and tell everyone that identifies himself/herself with the other 10 or 12 positions that what he/she's doing is not just simple, boring, and predictable (since it's so easily categorized) but also "not real art." I personally don't share this opinion. I don't think art or being an artist is exclusive. And I don't think that you teach art by describing it this way—I think you will lose talented, dedicated, and hardworking people because they will not just be discouraged by this but also fed-up with such an elitist approach.

My second concern is our use of "metaphors." I just wanted to remind you that we are still excessively depending on a pathological terminology: Depression, Psychosis, Addiction, OCD. If I understood it right, we are using these terms as "metaphors," and I just wanted to state again that we are very much inscribing ourselves in the long discourse of the "suffering artist," which I personally think is outdated, or at least should be outdated, because again I don't think that young artists benefit from being constantly confronted with the analogy of their art-making process with clinical diseases. It configures the way you experience the art-making process, and I don't see any benefit in declaring it as a disease.

Again, you can say that these are just metaphors for producing art, but since so many people and especially artists have used exactly the same wording before us—artists

that actually suffered from real depression, anxiety and psychosis—I think it will be heavily predetermined how people/students understand this. In my opinion we won't be able to give it a different twist.

Maria Ordóñez

Dear Carla (and all of you),
Thanks for sharing your thoughts with us. About your concerns, I have to say that all this has been quite challenging for me because of my dislike about the characterization and/or the archetypes solution (or process). Maybe this was the main reason behind my muteness in most of our sessions. Following your suggestion "... describing our individual artmaking processes [...] the way we create," I think it can be useful to give space on the "white sheet" for reflecting on this perspective. According to this, the idea (Artur's) about asking/discussions/interviewing artists, art teachers, and art students, is powerful in the way of opening this process to others. Instead of continuing to focus on a top-down perspective of finding "profiles," "archetypes," like (sometimes) design thinking does.

My proposal to all of you is to expose "ourselves" in this complex process and invite others to join our conversation.

1. How can we be exposed and transform in the "visual conversation"?
2. How can we expose others (from their own experiences)?
3. Can we rethink all the insights (map) taking as a baseline our own creative processes, stages, and triggers?

Anja Nora Schulthess

I understand you being uncomfortable with this categorization. But I think categorizing something that belongs necessarily to thinking / verbal communication / theory. Why should we deny it? And I think there is a kind of ironic and provocative gesture in this typology. For me it's not a final answer or solution but first of all claims, which can be useful for a discussion / for further thinking about these questions.

I also don't see that this typology implies that everyone except the alchemist is doing simple or boring stuff. But I think it marks certain possible problems involved in the process of being "creative."

For myself it's not helpful to claim that everyone could (and therefore should?) be an artist. I'm more interested in reflecting on certain positions from where we or others practice / ask questions and so on and think about these conflicts. (For example the Desperado who—instead of keeping on going with the question "who am I" or "what do I phantasize/imagine about the unknown Other"—is obsessed with getting an answer from the other.)

Fig. 11–12 Proposals by Maria Ordóñez: affirm/deny the image.

I don't know the reason why you're so uncomfortable with it; something personal? or is it the categorization itself, which necessarily brings a reduction?

Maybe it's helpful to see all this not too seriously, but rather as a play, as a playful and possibly productive chance to think and reflect.

Artur Żmijewski

From my perspective:
» the goal of the workshops is to investigate artistic creative process (not the creative process in science, for example) and define how such a process could be controlled—and as a consequence "how to teach controlled creative process"

» that's why we started with the "typology of the artists"—to somehow "frame" this mysterious figure of the artist, catch it, and categorize it—which means in fact to create manipulative access to such a figure for us, to have our own terms which could create deeper understanding of artistic practice

» in fact this typology is more ironic than serious—but there is still something serious in it (it's like in those two movies with Slavoj Žižek: *The Pervert's Guide to Cinema* [2006] and *The Pervert's Guide to Ideology* [2012]—is it really a serious way of making hard philosophy to comment on feature films? I don't think so, but ...). Do you know Freud's *Zur Psychopathologie des Alltagslebens*? It's one of the books that helped us understand human behavior, but it contains collection of funny and half-ironic stories from daily life describing all these small verbal mistakes—and it sounds like written in a coffee shop during afternoon break; to create our own terms also gives us autonomy of thinking

» I proposed a typology because it comes from my own creative practice; for example, I was many times confronted with the situation in which I did not develop an answer in let's call it the "self-debating process"—the answer appeared unexpectedly in my mind as a complete form; that's why I called such a process "Samara"; it's my own term, but others exist; for example Žižek could say that "it's not me who speaks, it's the Big Other speaking through me"; Marie Louise von Franz used the term "sudden ideas" to describe such a phenomenon of unexpected appearance of a complete idea/concept in someone's mind.

» I would keep typologies (new typology appeared: typology of art schools) to not be blind and in fact to not be lost in a stream of all possible individual differences that characterize artistic practice; I did not say that only the "Alchemist" produces art—other "types" of artists also produce art. The difference is that the alchemist aspires to control the creative process, the other "types" not really; there are talented people, hard working, devoted to their studies, but there is also the fact that only very few of them became artists – the question remains as to why

» partially used "medical terminology" linked to illnesses—maybe it comes from the pessimistic view on the artistic practice? There are probably art students who dream of being an artist; but is it really a good healthy job to spend life under a precarious conditions, being exposed to turbulences of mysterious uncontrolled creative process, social judgment and so on? "We have a perfect term to describe a fulfilled dream—it's a nightmare"

» such a "medical terminology" was also used in a neutral manner—for example, to initiate discussion about the "mechanics" of creative process we used the term subconsciousness; as Lacan said, there is constant circulation of rhetorical elements in human subconsciousness, some of these elements can be elevated on the level of consciousness; so subconsciousness has a structure of language. One of our questions could be how to create controlled access to this subconscious container of rhetorical elements? How to be flooded by the wave of subconsciousness and not sink (as Titanic did) but to swim normally? So, it's a metaphor of a psychotic episode when a single person is flooded by uncontrolled subconsciousness content and starts to behave strangely, hears voices, hallucinates, and so on; in our version of this metaphor subconsciousness in not an enemy but a partner (not chaotic but structured as a language, carrying interesting message) who could help us to "create art"; the problem is that we don't know the exact address of this partner; sometimes we are able to meet this figure by accident when we hallucinate during the day (Samara, Savant), but how to make it on purpose? and how to repeat these meetings when we want?

» we were saying that emotions which appear during the creative process come from the process not from the internal life of the artist/alchemist; the artist/alchemist who feels depressed should be aware that this "depression" comes from outside and it has a certain role to perform: to create distance from the world, from ordinary life—somehow to create silence in which very subtle sounds/voices can became noisy

» I think that this way of thinking creates an opportunity to have a polemic debate in which different opinions can be included; I would understand emotional involvement in the debate as a good effect of our discussions; we were talking about the emotions: what to do with emotions provoked by the certain creative process? We could understand emotions as a guideline and follow them trying to keep the track.

Nastasia Louveau

I would like to comment on things and ideas being shared, and I don't know where to start. I am fully affirmative in using Arthur's typology because somehow it matches my own reflective, ironic way of coping with issues: a continuous dialectic exchange first with myself then with others, categorizing, commenting, reflecting, playing around with ideas in a way that might at times come across as authoritative and normative (maybe even judgmental?), but that comes mainly from a playful, tongue-in-cheek, self-confident spot within me eager for intimate, sincere, and deep exchange with others. I wonder where the uneasiness comes from: what soft spot does it tickle? I find Wiktoria's thinking in "modes" and including the time axis into the "equation" into the static model of the typology very helpful, as it brings a dynamic, operative dimension to the chart that the criticizers of the typology might have missed.

And still I understand some of Carla's concerns. Our use of the pathological terminology as a reservoir of metaphors for the artistic process does jump into the beholder's eye, I agree. I really don't think there can be "a neutral manner" of using "such a medical terminology," as Artur puts it. This terminology has a long history of (institutional) violence, of excluding and marking individuals as "others," and while using it we have to be cautious as how we affirm this history without reflecting on it. But I also wonder from what place each of us is using these "diagnoses," these concepts of the Junkie artist, the OCD, or for example the lonely, down phase of depression in the creative process? Do you believe in the psychiatric diagnosis or do you question it? Do you see OCD, addiction, depression, neurosis, etc. as given, as illnesses with hard outlines that concern some people who thus are patients in need of care? I would rather subscribe to a radical anti-psychiatric view in which these facets of personalities all belong to the spectrum of human life and emotions. In this view it is the psychiatric institution that creates the tangible profile of the Neurotic, the Schizophrenic, the Depressed and that marks him or her as ill, creating a foil (the diagnosis), a social role and function with which the person identifies, thus becoming ill. With this statement I do not ignore the suffering of people with such diagnoses, and their surrounding environment (friends, family), which is very real. But I would like to propose a thinking about these mind frames and strong emotional states in other terms, outside the othering power of psychiatry and above all avoiding the identification with the social role of the ill. Do you know what I mean?

Now, reacting to what Artur is asking: "Is it really a serious way of making hard philosophy to comment on feature films (such as Žižek's practice)? I don't think so," he says. Well I do think it is a very serious way to do so, as films think by their own—cinematographic—means, so commenting on them might help highlight and understand the films' way of thinking and articulating the world. To me there is in the artistic creative process something like art's thinking on its own, the material's thinking, the hands' thinking—all of them being non-verbal, non-cerebral cognitive processes.

In my own artistic practice, they are one side of the medal (for example, portraying people and painting), the other side being the articulated, dialectical, introspective, "desperate" drive for exchange and reflection that is very verbal, sometime even "textual" and always very attuned to said emotions. I would be interested in a diary of the participants retracing their emotional involvement over the course of the workshops. Some ideas so far.

Reacting to your last thought/paragraph, dear Carla, I wonder: can there be a theory (of art and teaching, of teaching art) that is not intimately bound to its practice? Is a position as a non-participating, non-practicing, solely theorizing, external observer and commentator possible? (Like, absolutely and utterly possible? And/or, regarding our workshops and their setting, possible and thinkable in our case?) Aren't we all speaking from practicing, practical, emotionally loaded positions? Isn't emotion always part of the process (the communicating, creating, thinking processes, etc.), and as such something not to be afraid or ashamed of and rather, as in Artur's alchemist metaphor, something to consider, to include, to reflect upon in order to better understand and control what's happening and what's being said? Do you think there is such a thing as a wrong reaction? Why is that? What is this judgement based on? I don't think there are right or wrong reactions, and I find your propositions (visual as well verbal) very inspiring; they prompt lots of ideas of my own, and this I find very valuable. Your emotional involvement also shows a certain commitment to the topic, and this sharp, at times defensive tone of yours might be a way to make yourself vulnerable in the exchange (sharing deep, intimate opinions without knowing what you're gonna get in return— maybe the reactions are going to hit you badly or maybe reward you, but that you can't know in advance) and protecting yourself at the same time, not making yourself fully vulnerable. (Who could blame you for that? Not me.) Can you relate to what I am saying? Or am I way off and moving into a territory I should better leave asap? If you find it offensive or "grenzüberschreitend" in any way, please tell me—I truly hope my speaking from a well-meaning, warm-hearted position is tangible.

Fig. 13 Proposal by Nastasia Louveau: affirm the image.

Carla Gabrí

Artur, I see. Defining the question of the workshops a little more precisely as "how to teach to control the creative process" is a game changer for me and my thoughts but it certainly meets with what I have experienced in the workshops so far.
I think I also understand your approach to the typology better than before, or at least I see where you are coming from.

I'm with you when you say that creating our own terms gives us autonomy of thinking, BUT I think this has the very logical consequence that there is even less reason to rely on an overused, and often also intentionally misused, medical terminology. So why are we not just finding our own terms for describing different stages of the artmaking process?

I find it very valuable to hear about your experience and development as an artist. But I also want to point out that, on the contrary, you never asked us about our experience (asking us to position ourselves within your typology isn't the same because you already put us in a format of yours). Talking from your experience and the way you solve certain problems that arose while practicing art and, subsequently, setting it as a standard is problematic in itself. It will be suitable first and foremost as a guideline for artists who are like-minded and who share a similar approach and attitude towards art. But, for example, I don't think it's universal to struggle with gaining control or to need guidance when it comes to starting a reflection-process. I cannot speak for all the others out there, but I am led to believe that the need to control the creative process is in itself something that only a certain type of artist needs. For example, I am badass good in controlling and reflecting, but I am not yet a badass good artist. So how can this be? I personally think that for me constant reflection and the wish to channel my creative output in a controlled manner is potentially exhausting and also boring and/or paralyzing (not just temporarily, it can make me stop forever). Maybe we can say that I, for my part, can improve my work by learning to "control my control" and constant need for reflection.

Fig. 14–15 Proposals by Carla Gabrí: deny the image by turning the page.

Artur Żmijewski

Extension of the Typology of Artists—(Subjective) Summary, May 2

1. discussion started with the extension of the typology of artists—new types were included:
» Desperado (person who desperately wants the other to react: tell me who you are? but also represents hysteric position: tell me who I am?; it's this artist who repre sents cognitive approach)
» Shaman (Beuys, Abramović) = conservatism, someone who uses well known forms, well rooted techniques and so on; example of "conservatist": Roman Opałka who was devoted/addicted to numbers
» and Shaman Being (there is no difference in his/her life between ordinary life and art practice); no border between inside-outside)
» Madman/woman (existential destructive being)
» Junkie (OCD / obsessed with the creative process, addicted to it)
» Delegator (make art instead of me; queen bee versus workers)
» Prosthetic Man (art seems to be a prosthesis / artificial limb / she/he needs it, it's a part of the body)

2. some types of artists were defined as social functions (Functionary, Lifestyle Researcher, Artisan, Politician) when the other were defined as "function of mind" (Savant, Samara, Calculator Man)

3. typology of art schools / art teachers appeared:
» Mute Teacher (doesn't speak just proposes "hmm, hmm" as a comment);
» Active or Talkative Teacher—divided into a) Socrates, asks questions b) Injector c) Master; there is no interaction with him/her
» I would add d) Partner (sparring partner but also polite intruder into a creative process)

4. there were comments about the art education as a "selection process" and the general question "Why do we teach art?" (not developed)

5. there were questions (not developed):
» how to teach parents to let artists appear?
» how to teach society to let artists appear?

6. there was also a proposal to think about the "mechanics" of the creative process (not developed):
» there is a circulation of rhetoric elements in our subconsciousness
» these elements have the ability to appear sometimes on the conscious level

Fig. 16 Proposal by Valentina Zingg: deny the image by crumpling the image.

» the question is how to let them appear on the conscious level when we want them to appear?
» the metaphor of the "psychotic episode" was used: how to be flooded by the chaotic content of subconsciousness and not sink but swim normally?
how to create controlled access to the collective subconsciousness and use elements taken from this level in the art-making process?

Artur

Artur Żmijewski

De-compose / Re-compose Body Parts—Individual Exercise #2

De-compose / re-compose body parts (use digital camera to take photographs, manipulate images digitally)

The idea of the exercise was to focus participants on this very old and very exhausted issue called the "nude" or study of the human body—and to prepare them for another expected exercise: study of the old body—body of elderly people. Participants were allowed to somehow transform the body of the other into an object of interest (in a non-violent way), object of manipulation, field of cognitive studies.

Fig. 17–18 Theory Development Sheet, detail in black and white.

Fig. 19 Proposal by Maria Ordóñez: de-compose/re-compose body parts.

For now, I started exploring my own body. During this I faced the strong necessity of a detailed, distorted, and fragmented perspective. After some days of search I found that augmented lenses also work as screens in themselves. In my research I came across a drawing made by a woman that looks for her disappeared son in Colombia. She makes use of these types of lenses as a metaphoric way of making something appear/emerge/augment. So it is related to the way I have been exploring my body as part of the workshops' tasks. These exercises are barely what I was able to do working by myself. Soon I will upload more controlled shoots, and other digital experiments of recomposing body parts. Work in progress!!!

Anja Nora Schulthess
May 04, 2018

about the typology of art teacher i was thinking about rancière's concept of the ignorant teacher ("der unwissende lehrmeister"—book i would recommend) which has a positive connotation in the sense that the teacher doesn't hide his lack of knowledge or does even make it a subject of discussion. teaching in this sense would mean a dynamic between teacher and student; between two ignorants. it's not about changing roles but about the negation of active-passive / the one who acts and knows and the one who spectates and learns.

Nastasia Louveau
Ay! I had totally thought of this text too! It doesn't only concern the teaching of art, it is also meant as a general reflection on pedagogy, on teaching and learning as a general reflection on pedagogy, on teaching and learning as emancipating processes:

"It's not a matter of making great painters; it's a matter of making the emancipated: people capable of saying, 'me too, I'm a painter,' a statement that contains nothing in the way of pride, only the reasonable feeling of power that belongs to any reasonable being. 'There is no pride in saying out loud: Me too, I'm a painter! Pride consists in saying softly to others: You neither, you aren't a painter.' 'Me too, I'm a painter' means: me too, I have a soul, I have feelings to communicate to my fellow-men." (Jacques Rancière, The Ignorant Schoolmaster, 1991, p. 67)

Wiktoria Furrer
Me too. For me it is interesting that Rancière's stake goes beyond the pedagogical relation and beyond the (im)possibility of knowing,
It is a thinking of the potential of equality. Still many things are enigmatic to me in this book, though. Let us talk about this one day!

Fig. 20–21 Proposals by Wiktoria Furrer: de-compose/re-compose the image.

Fig. 22 Drawn note by Nastasia Louveau.

Doubts—(Subjective) Summary, May 7

Doubts were the main topic of the meeting:

I. lack of focus on individual creative processes (presented during discussion by Carla) Gabrí combined with the question: what is the mystery of "badass good artists"? how to "make" them? If control is maybe not the best strategy to produce high quality art then what is such a strategy?
the proposal was to be focused on a very few individual cases and check what kind of education "produced" certain results; what kind of personal approach lets high-quality art be produced?

II. some terms taken from "medical" terminology—the discussion circulated around possible "neutral" use of such a terminology
I mentioned again that for example using terms "psychotic episode," "subconscious," I'd like to talk about the mechanism of the creative process in which certain person is flooded by the content of collective subconscious—and is happy because it gives her/him access to the collective mind, collective fantasies, perversions, anger, and so on—these elements that could be used in "art's creative process"

III. emotions—important factor of the process—emotions force us to choose certain strategies, but could also block the process; Nastasia proposed in her comment to write a "diary of emotions"—to transform them into something "visible on paper", framed, somehow reported and understood

IV. proposal by Wiktoria to develop understanding of artistic "thinking," which is different from the other ways of thinking, unique, much more material—and still mysterious

V. there was a question about the exercises—why are these exercises "safe"? Maybe it would be possible to have exercises that would really be about ART with all its tensions, destructive-creative emotions, and even with body symptoms; that's an interesting question: how to create within a "school frame" conditions for artistically advanced experiments?

V. there was also a kind of semi-agreement: let's use different vocabularies and different terms to follow the process even if it's impossible to erase doubts or reduce their presence

Artur

weight decay

not
individual
cases

it's a punitive
approach

multi-phasic

Artur Żmijewski

Enlarge Selected Image—Individual Exercise #3

Enlarge selected image (from the newspaper *Le Miroir*, 1918)

Participants were asked to enlarge the image, but it was not defined what this instruction meant. It could be transformation of the format (film, digital image instead of paper photography), measurement, distortion of the image, and so on. The idea of the exercise was to let participants look at the image in details, over-carefully, even obsessively. You have a sheet of paper with an old image printed on it and you research it visually, mentally, psychologically. That kind of meditative engagement or meditative research is usually one of the first steps in the creative process. But of course the object of "meditative research" can be different—for example a social situation or a certain political process, or the results of this process.

Fig. 23 Theory Development Sheet, detail in black and white.

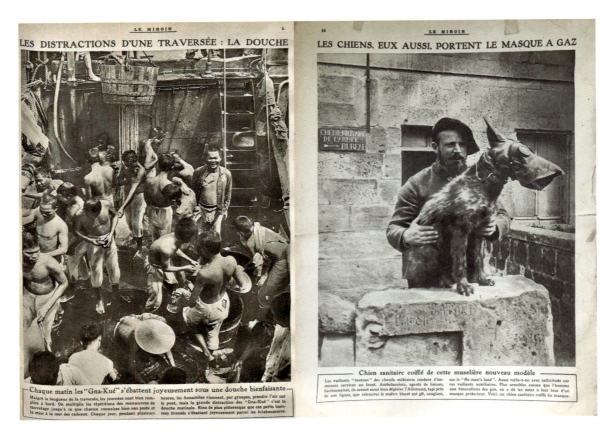

LE MIROIR

LES DISTRACTIONS D'UNE TRAVERSÉE : LA DOUCHE

LES CHIENS, EUX AUSSI, PORTENT LE MASQUE A GAZ

— Chaque matin les "Gna-Kué" s'ébattent joyeusement sous une douche bienfaisante —

Malgré la longueur de la traversée, les journées sont bien rem-
plies à bord. On multiplie les répétitions des manœuvres de
sauvetage jusqu'à ce que chacun connaisse bien son poste et
la mise à la mer des radeaux. Chaque jour, pendant plusieurs

heures, les Annamites viennent, par groupes, prendre l'air sur
le pont, mais la grande distraction des "Gna-Kué" c'est la
douche matinale. Rien de plus pittoresque que ces petits hom-
mes bronzés s'ébattant joyeusement parmi les éclaboussures.

— Chien sanitaire coiffé de cette muselière nouveau modèle —

Les vaillants "toutous" des chenils militaires rendent d'im-
menses services au front. Ambulanciers, agents de liaison,
fractionnaires, ils savent aussi bien dépister l'Allemand, tapi près
de nos lignes, que retrouver le maître blessé qui gît, sanglant,

sur le "No man's land". Aussi veille-t-on avec sollicitude sur
ces vaillants auxiliaires. Plus sensibles encore que l'homme
aux émanations des gaz, on a dû les doter à leur tour d'un
masque protecteur. Voici un chien sanitaire coiffé du masque.

Fig. 24–25 *Le Miroir*, Paris, no. 207, November 29, 1917 and no. 234, May 19, 1918.
During World War I this illustrated newspaper was full of photographs presenting combat zones, soldiers, cruel scenes, and usually very depressive surroundings of places affected by war.

Fig. 26 Proposal by Nastasia Louveu : enlarge selected image and convince viewers that you like it, 1.80 x 2.40 m. Short insight into the creative process:

I am in the middle of one of the previous exercises [enlarge the image, optionally criticize it or convince viewers that you like it]—Picking this particular image, I was attracted by this overcrowded scene of bathing/showering on a ship, by the many half-naked male bodies, by the plasticity of the photograph, I was immediately drawn to it: I "saw it" in my mind as a huge painted poster and it immediately reminded me of a Japanese proletarian novel of the late 1920s called *The Factory Ship* by Kobayashi. This novel is "proletarian" insofar as it has not one hero whose story gets told, instead it is the whole ship crew, the hundreds of sailors and workers of the ship who build one collective protagonist. Now back to the photograph from *Le Miroir* newspaper: this picture shows soldiers from the French colonies in Indochina (from the Annam province, currently Vietnam) who were sent to France as reinforcements during World War I, in 1917.
My thought association with the proletarian novel (even though unrelated to the facts surrounding the photograph) contributes to the intuition that my enlarging this image, simply making something with it, will most probably shed a critical light on it "as if by itself", making the othered, colonized, exploited, undressed men of the photograph protagonists of a story of their own. Mostly, I have the intuition it will comment on the content, on the objectifying gaze of the photoreporter. (But does that work that way..? And is it the only thing it does?) Plus I am myself convinced (or at least, I hope?) that such an enlarged view of the photograph—and a drawn and painted one on top of it—will be a very sensuous, haptic experience for the viewers. From the chosen perspective (same as the photograph) and the pictural choices it will be clearly an affirmative, positive, maybe even loving take/gaze that I propose on the image.

Fig. 27 Proposal by Maria Ordóñez: enlarge selected image, 1 x 1.50 m.

The video is called "Matters of Space". It's with sound.

Fig. 28 Proposal by Carla Gabri: enlarge selected image by zooming-in.

Carla—(Subjective) Summaries, May 14

The main topic of the meeting was "Carla" and her autonomous creative strategy. I used the word "Carla" in quotation marks to somehow separate this term from the living individual. Following Carla's request to be focused on individual creative processes, we were focused on her process. Carla told us how she works (please correct if there are mistakes in my notes):

» in her case there is always a very logical initial phase of the creative process (art making process); she defines the problem or the topic; then she defines the time frame, tool, and the way how the artwork will be done; this is a part of the process which is highly controlled and even predicted by her (it's a repetitive strategy in fact)

» when all these coordinates are defined and fixed, she is able to experiment with images, material, and so on

» she is even able to be obsessively focused on selected topic and doesn't feel bored or tired during the experimental phase of the process

» but this is exactly the very moment when she loses control—the artwork becomes a "set of bricks" that can be organized differently, modified, transformed, re-configured—she is active until she knows that this is exactly what she was looking for; the artwork is present in front of her in a complete form—but there is a price (as I understood correctly): she loses interest in the art work itself and in the issue of it when the artwork is ready.

There was a proposal to include this "type of the artist" to our typology—Carla proposed "Carla" as a name of a certain artistic strategy (re)presented by her. So "Carla" was included with number IX to the list.

This type of artist shows us something very interesting—they create situations in which intuition can work. All these mental coordinates and logical steps towards the art production should let intuition work. Rationally created conditions should help the artist to lose rational control and then let new forms appear.
So control creates conditions to lose control in a kind of suicidal act.
The conclusion was that it's exactly something what could be a part of education process: how to create conditions in which intuition and "chaos" could effectively appear, then work and conclude with art work?

Of course subsequent questions arise: how to work with intuition and chaos "provoked" by us? How to work with the lack of control? What if we do not simply manipulate images or certain material but we are in social surroundings that are not clearly structured, untransparent, maybe dangerous? How to let intuition work in such an environment? What if the topic of our work or our question is not defined, is

hidden or access is blocked? And how to ask "proper" questions as an artist, so as to be a badass good one? How not to be focused only on aesthetic practices?
These are interesting problems that could be elaborated collectively. What do you think?

Artur

* * *

14.5.18

I think
there is a
need for
control –

a repetitive
procedure

a game

the hardest
for an
artist is
to set up
a framework
of one's
own

Carla G.

Fig. 29 Nastasia Louveau: Carla's process.

The main topic of the first half of the meeting was my autonomous creative strategy. I will not put my name in quotation marks to separate what I said from me; instead I will just write as a living individual, coincidentally named Carla.
Following my request to be focused on individual processes, we focused on my process. So I tried to illustrate how I work.

» In my case a new artmaking process usually starts with me trying to configure relevant frameworks. If the topic or the task comes along with specific requirements/ challenges, I will consider them as game rules that need to be addressed or as a field I will position myself in relation to. I will consider the time frame, as well as the accessible, affordable, and usable material/media/possibilities I have. This part of the process is highly controlled but not necessarily bound to conscious choices. I think I already repeated this so many times that this can establish itself quite automatically
» When all these coordinates/frameworks/game rules are mapped out, I am able to play with the chosen material/approach in an obsessive manner, since this is the part I love the most. This part is highly intuitive, spontaneous, uncontrolled, and the outcome is always unknown. (if it's not unknown I will not even start it)
» I will stop when I am satisfied with the surprise of the outcome
» I will then again intellectually frame/polish this outcome in a way that matches/addresses/tackles all the frameworks I set up in the beginning. I consider this particular step not as something very exciting, but rather as a job—something you simply have to do if you want this surprising thing you created to be accessible to other people.

In general I think that there is a time window / expiry date for every artwork I could possibly make in my life. Not just the opportunities I have are shifting constantly, but also my interest/motivation/fascination. So I try to work as fast as possible to get as much done as possible.
 "Artur" proposed to include this type of working process to our typology. I jokingly proposed to name it "Carla." So "Carla" was included with number IX to the list.
 While reflecting on this "type of artist named Carla" I mentioned that being able to recognize/ establish/invent frameworks seems to be crucial if you want to make art on your own. In real life no one gives you frameworks. No one asks you questions. No one gives you rules to play by or break.

Although I think that setting up frameworks is a tactic I have developed over the years, I still have some serious challenges in front of me. For me the relevant questions are: How can I start asking more complex questions (I have the tendency to tackle only things that I can somehow grasp intellectually)? How can I reproduce this working procedure when I am working on questions/frameworks that are not just aesthetically but also socially/politically relevant? How can I push myself out of my geometrical comfort zone? And, as Artur has already articulated, "What if we do not simply manipulate images or certain material but we are in social surroundings that are not clearly structured, untransparent, maybe dangerous?" How to let intuition work in such an environment?

Carla

dynamic
between
teacher
and student

copulate

I've ejaculate

Artur Żmijewski

Co-regulate / Irregulate—Individual Exercise #4

Co-regulate / irregulate (find a place in the city of Zurich or other Swiss venue, try to be confronted with / be aware of / understand the rules which define the chosen place, then co-regulate it / irregulate it, document the process/action)

Participants were asked to define rules that organize certain parts of the city—a part of the street, a square, corridor inside a building, and so on. Not only rules that are quite obvious—for example traffic regulations—but also those invisible rules that come from the collective mentality, from unwritten collective agreement, from very local habits, and so on. The idea was to take part in the creation of these rules but also in the negation of them. When we were talking about the proposal of this exercise we realized that all these rules are so deeply internalized that participants are not really ready to make this exercise happen. Finally just one answer was made—one that is quite ironic and non-violent.

Fig. 30–31 Theory Development Sheet, detail in black and white.

Artur Żmijewski

Human Geometry of the City—Individual Exercise #5

Human geometry of the city

Participants were asked to record situations arranged by them in the city. The situation could present a meeting of two geometries, two shapes: human, organic shape, and human construction (buildings, streets and so on). Short films could be edited.

Fig. 33 Theory Development Sheet, detail in black and white.

Wiktoria Furrer

Dear all,

I share some notes that against their maybe predictive tone are an uncertain state in the middle of a work in progress.

Freud's main thesis of in *Psychopathologie des Alltagslebens* states that the disability of psychic functions (misspeaking, forgetting names, creating cover memories) is well motivated and determined by motives that are unknown to the consciousness.

However, from the perspective of the subconscious these malpractices are not insufficiencies. On the contrary, they are a manifested ability of the subconscious to actively speak. Subconsciousness speaks through ver-sprechen, ver-gessen, ver-lesen, ver-schreiben—linguistically interestingly constructed via a prefix that describes change, destruction, or erratic behaviour. In those failures, cracks, and fissures subconscious content displays itself. By doing so it simultaneously irritates and perforates the surface of the actual practice (for instance the practice of telling a story), as well as the habitus (the specific dynamics of the habit of conversation between two friends).

In this reverse perspective, erratic practice itself becomes an event that is aligned with an emerging experience that is unpredictable because it exceeds the imagination "ante." As these events nevertheless lie within the structure of practices in their vital, ambivalent nature, they have a micro constitution. The consequences of an apparent misspeaking can lead to serious conflicts, so it seems clear that micro-events should not be underestimated. Micro-events can incite with a force majeure.

They can be seen as "eventful forms of knowing" / "events of knowing" and extended to wit (ingenium, esprit), coincidence, lucid dreaming, radical imagination. This proposal disagrees with concepts of knowledge production (Wissensaneignung vs. Wissenproduktion) as it reaches towards subconscious and contingent streams in the self, collective, and society.

Fig. 34–35 Proposal by Wiktoria Furrer: human geometry of the city.

theoretical (t) terms

neutral (c) way

exceptional state:

psychotic

maniac thoughts

guarseind

paka

Artur Żmijewski

Study of the Hand—Individual Exercise #6

Study of the hand (with use of digital video camera)

Participants were asked to make a short video that focuses on hands. So it's a study of the human body limited to both hands and their movement. The idea of the exercise was to study the human body in a fragmentary way, reduced to small parts. It seems to be difficult to make an interesting story about hands, but it was necessary to prepare students for the next exercise: the study of the bodies of elderly people. We expected this exercise to be difficult because of the contact with people who are on the edge of their life; their bodies don't work well. Such a contact creates strong emotions—when you feel strong emotions you cannot really work. So it is good and necessary to be experienced and work "automatically" when you are confronted with such a difficult subject. You can even feel deeply depressed when you film a person who is going to die soon, but all the problems like light, composition, plot of the movie, and so on are already solved and you are able to work. Even like a robot. But this is one of the difficult issues: how to continue your job when you work in a very tough situation? In my opinion artists should be prepared for such situations in advance.

Fig. 36 Theory Development Sheet, detail in black and white.

Fig. 37–38 Proposal by Valentina Zingg: study of the hand.

Fig. 39 Proposal by Maria Ordóñez: study of the hand.

84

Fig. 40 Proposal by Carla Gabrí: study of the hand while competing in the Idiot task (separating a paper sheet and gluing it back together without ripping it) to determine which one of us belongs to the artist type called the Idiot.

Visual Discussions—
Collective Thinking

Fig. 41–43 Black-and-white photographs documenting the collective visual discussion with the skeleton and the face-mask exercise; taken by Nastasia Louveau with a Zenit camera.

Fig. 44–49 Collective Visual Discussion, 02.05.2018.

Fig. 79 Blackboard Conversation, 11.05.2018.

Fig. 80 Theory Development Sheet, Exhibition
100 Ways of Thinking, Kunsthalle Zürich.

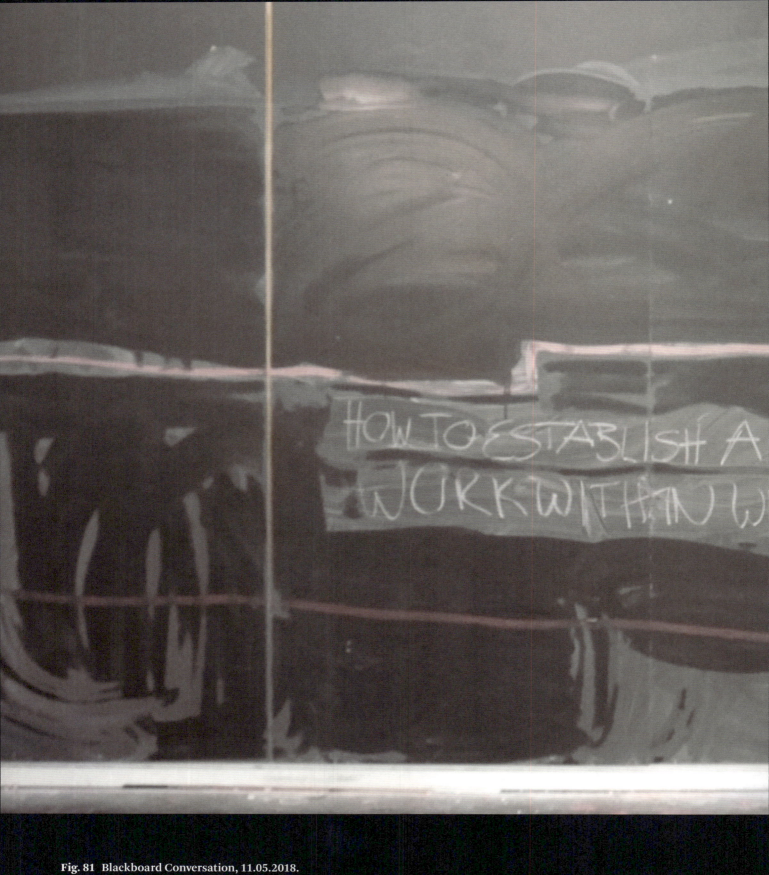

Fig. 81 Blackboard Conversation, 11.05.2018.

PAUSE

...NTROllED FRAMEWORK TO
...N)THE TOPIC IS IN)ITSELF

How to establish a controlled framework to experiment within, when the topic itself is uncontrollable?

filling the empty space
filling the empty space
filling the empty space

Fig. 90–95 Blackboard Conversation, 11.05.2018.

Fig. 96–101 Skeleton, Study of the Human Body, 9.07.2018.

Fig. 102–107 Blocks for Kids, 20.07.2018.

SUBCONSCIOUS

RETHORIC PROCESS

FUNCTIONING

MECHAN.
DEF.

CREATIVE
PROCESS

(LEVEL OF CONSCIOUSNESS)

Artur Żmijewski

Camera Test—Individual Exercise #7

Camera test (working test of 100-year-old Voigtländer, format 9 × 12 cm, b&w)

The old Voigtländer camera was tested during the meeting. The main purpose was to check if the camera worked properly, if the shutter worked as it should, and so on. But also analogue photography was introduced to the students. This is something that we do not really control, living in the digital era. The idea of using this Voigtländer camera as part of the course was to expose participants to an "image recording process" that is somehow out of our control. We asked the Voigtländer to "help us." I have this idea that old cameras have a soul—what is this soul? It's a specific way of reflecting reality that is not 100% mirror—cameras from the beginning of photography were a kind of filter. People constructed machines that were able to encrypt people's emotions because people did not really differentiate themselves from the material itself. So in my opinion the old Voigtländer transfers emotions and is a little bit out of control.

Fig. 112 Theory Development Sheet, detail in black and white.

Wiktoria Furrer
May 6, 2018

» on making art as a thinking mode

I think the artistic process is actually more about thinking than about control. Somehow control does not seem the right criterion to me.

I would like to think about making (but maybe also perceiving and even teaching) art as a specific (different from others) mode of thinking—a thinking in, through, and with art. Practicing art appears as a configuration of thought, which includes subconscious streams and involves (self-)reflection.

For instance, at first sight it might seem that an artist who sees images (Samara) is exposed to an external and uncontrollable source of creative force. But is this true? Would it mean then that the artist sees images like the children of Fatima see holy Mary, or a psychonaut on LSD sees some psychedelic forms? Then this process of seeing would be more mystic (Fatima) and neuro-pharmaceutical (LSD trip) than artistic. In this case it would be more effective in terms of learning/teaching to find a spiritual practice or the perfect micro-dosage. This is not quite my expertise. This (sudden appearance of images/ lack of control) also would engage a classical and outdated perspective on artistic practice—"in spirare", being passively exposed the external breath/spirit/animus. At the same time, even in my profane theoretical work, sometimes I simply see solutions in front of me. But is this true? Or is it rather the last, superficial layer, only the peak of a much bigger iceberg? Those images, which pretend to be there—"They simply are," as Samara says—still come from somewhere. Where do they come from? How do they come into appearance and why?

I think this could be a starting point for our discussion. Another example: during the exercise of responding to the given image, again I clearly saw the answer in front of me, a blue form (head) on red background. Then I drew it, like making a copy. But this view reduces a much more complex process of thinking in advance—I analyzed the image for quite a long time, and I recognized the ambivalence of threat and submission that vibrated from it. The "inner image" unconsciously of course referred to collective memory and the symbolic meaning of colors (in a most simplified view, red—life, warm / blue—death, cold). Under this premise art-practicing has an own status of thinking, is more equal (not only the chosen ones) and might have a chance of being taught.

Fig. 113–114 Photographs taken by Wiktoria Furrer and Carla Gabrí.

Artur Żmijewski

Architectural Composition and Self-portrait—Individual Exercise #8

Architectural composition and self-portrait

It's a combined exercise—the human body / the human entity can be understood as an object; it is the idea of the exercise to practice how to treat our own bodies as objects; the goal is not to dehumanize people but to "use" them as artistic material, as existential material; and to find out how to transform them into the artistic message (image, art work) without being paralyzed by moral judgment and without hurting anybody, how to respect dignity of the "object"; so there are two "objects" to be photographed with quite similar coldness: the own body of the photographer and the architectural entity.

Fig. 115 Theory Development Sheet, detail in black and white.

Wiktoria Furrer
May 21, 2018

I understand that I must have been unclear in my talking, and as far as it is at all possible for me (because maybe the topic is black-boxed, meaning inaccessible to myself) I want to come back to it, but this time through different examples. In my work with and in art I was always focused on the potential to show, to reveal, to make something visible, or even to broaden perception. Being now immersed in this work through art exercises, a process that is to me very intense and fueling, I feel exposed to aspects that are undefined, unknown. Even though cognition is limited, including that I am also aware of my own limitations (for instance, lack of art-making experience, no typical art education, no technical nor visual abilities, no composition skills), I still suppose that this is more of a general nature—that it lies in the dynamics of the creative process—than only a personal issue. And as such I prefer to discuss it. Simultaneously as micro-practice and radical pedagogy, the field I work in is not only about art and not even clearly scientific, but touches by definition the very existence. Via asking how change is possible (aesthetic of existence), I cannot separate and distance myself from the topics I work within.

So this is an attempt to reiterate what I said today about the, in my eyes, ambivalent structure of artistic processes, which seem both to reveal something in a specific, maybe unique way and to leave something unknown, unrecognized, and in the shadow. This afternoon while we were discussing our Friday drawing session two images merged in my mind: the image of the blackboard—the instant that shows something, makes something appear—and the image of the black box, symbolizing the inaccessible. Artur has uploaded a photo from today that shows a black rectangle, one of three black boxes/blackboards (or black boxes–blackboards). The first, smallest rectangle represents the inaccessible parts of the self, referring to a black box as in an airplane (data flight recorder), the second pictures the blackboard as a display where something appears (as used in our drawing sessions); the third and biggest rectangle is covered with black paint in one corner—the other part was at first empty, and later filled with pink bubbles by Nika. This last form was an image of the process of our workshops—a space that makes something appear that in micro-events brings about experience and insights, but also lets something remain (or become?) inaccessible.

An example (interestingly meaning image in Latin):
Earlier on Friday I was taking photos and editing them and I was confronted with the question of how to know when to stop? When is the image finally composed? This "When to stop?" became a question on the blackboard. In the final scenes one can see Maria rotating in one position (left end of the blackboard) her hands up and down, drawing a circle. After a while Artur makes Maria move to the right side. But even after the blackboard ends she does not stop rotating her arms. After another while she stops, but still this is not the finale, even though it marks the end of a

Fig. 116–117 Proposal by Wiktoria Furrer: architectural composition and self-portrait.

longer action. Instead Artur brings a completely new object into the picture, a wooden stick, and leans it towards the blackboard filled with Maria's moving traces. My reading of the answer given by the collective performance on the blackboard was something like "you stop when you stop." The answer was not limited to something like "after the 27th attempt" (this is the answer to a mathematical challenge called the "secretary problem"), "when you find the golden ratio," or "on Monday." The answer manifested in a performative way, with an impressive reason. Specifically, the given answer did not reduce complexity, but even enhanced and expanded it.

As a formula or diagram only deals with a fragment (in form of a variable or unit, for instance) there is not much left to be unveiled or inaccessible because there is no need to exceed this self out-wearing frame (this is itself an under-complex description, but I need it for contrast). Literature instead narrates the complexity of life (literature as life science), and the artistic process could even be complexity increasing.

Another example:
On Friday we started with Carla's question about how to control, continued with the question on how to stop, and ended up with "Who is Carla?" One question was clearly induced by the other, leading by means of its own logic to the other. Also through all meetings one question led to another—how do artists think in art practice, how to control the process, where do images come from? and so on. Artistic process appears to me as problem-generating rather than problem-solving.

And the last example:
When you look at the photos of the images we have produced, you cannot recognize anymore what was there in the beginning. It was either blurred, erased, or substituted by something else. Our main working sheet grows in tectonic levels of paint, writing, and omissions, marked by black ink. Art as a form of knowing takes in this "unknown," those black boxes, and reflects on them instead of neglecting their existence.

Blackboards turning into black boxes and vice versa, this constant play of appearing and hiding of meaning, seems to be an ambivalent configuration in the artistic process. I am interested in this because it has some fundamental, social, and epistemic implications about how to teach art, and further about the way we understand and educate at all—how to deal with this shaky configuration? How to endure the process, as the self is transformed by this practice? How to speak about the black box without falling into the trap of empty euphemism like "magic," "mystery"? Should we invent our own language, because the jargon of "knowledge production" seems inapplicable in the light of what was said before? Let us try!

Can anyone relate to this at any point? As today was difficult for me, I would be grateful to discuss this further with you guys. If you think this is silly or it does not interest you at all, then please let me know, but I do not want to reproduce misunderstanding and I really need some feedback from you to work with.
Thank you.

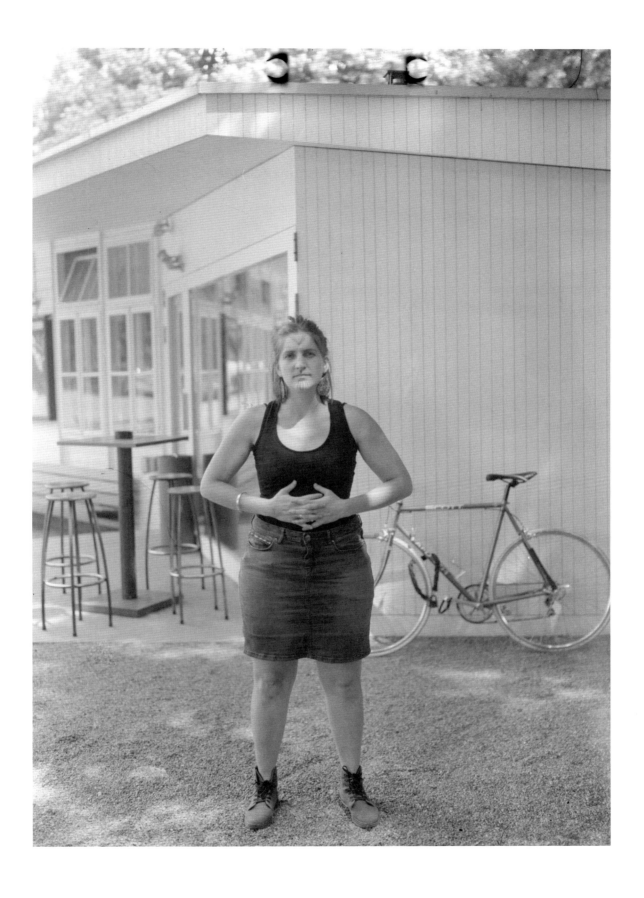

Fig. 118 Proposal by Nastasia Louveau: architectural composition and self-portrait.

Carla Gabrí

I relate to what you're saying and I want to make it clear that I do think that this was and still is an observation that is just as valuable as all the other observations we made so far. I was really unhappy with our last session. And I read your post, as well as Artur's reaction to your post a dozen times, but I still can't spot this huge contradiction/incompatibility between your arguments/approaches that would explain this clash we had last session.

Nastasia Louveau

Hey, what kind of a clash are you talking about? I sadly missed last session and I might miss tomorrow's, too—I'll be back on Monday for sure. What did I miss? What kind of affect was involved in the discussion you are referring to?

Carla Gabrí

I wish I could explain it to you accurately, but honestly I think that everyone experienced it differently. I think in general one could say that Wiktoria's observation mysteriously led to a discussion about the relationship between art and science, resulting in two different opinions: one that sees a strong, positive correlation between art and science and one that sees no correlation at all / regards "scientific thinking" in art-making processes as something very problematic.

Since pretty much all of us participants have strong academic backgrounds, and obviously also an interest in art-making it turned into a rather difficult/exhausting discussion. Anyway, maybe the others can correct me here or pin down the problem we encountered more precisely?

Wiktoria Furrer

Thanks Carla for recapitulating!

Just a short comment on only one fragment of what you write, namely the question of art and science that came up somehow: I was not and I am not (personally) interested in this approach. This discourse has been exploited by artistic research in the last two decades and does not seem very fruitful and generative to me. Instead I want to find out something about art and not about the difference between art and science. I think we are far ahead of this in our collective working process. I am interested in this "autonomous" status of art: what is possible within it? how is it expressed? what can it effect? For me this focus on art in a new way has to do with the proposal of the workshops themselves, where I realize that I am in a new learning process that is connected to unlearning things I thought I knew.

Fig. 119 Proposal by Carla Gabrí: architecture composition and self-portrait.

Artur Żmijewski

Here is my reaction to the comment by Wiktoria:

» art by definition produces unclear messages, but that's its freedom—as an artist you are not obliged to propose defined conclusions; you are allowed to confront yourself and viewers with complicity in the problem, with the foggy and ambivalent nature of it; significant art is something what makes problems much more painful, makes the dark abyss deeper and the cracks wider

» but it's possible to analyze the artistic process and its consequences; in case of the blackboard and a question "when to stop?"—when is the artwork done/complete?—the process of drawing we went through was not only a stream of single images (appearing and disappearing) but also a "time based cinema-like art piece"; time was an important factor in the process—time was included into a composition of the art piece and became a ruling part of it; the final "product" is a movie based on the stroboscope effect—instead of fluent appearance of changing blackboard panoramas we jump from one moment in time to another; we were collectively drawing on the screen in this reversed cinema—occupying a position of light that normally produces images on the screen; of course it was a situation in which we were the cinema light, which "doesn't know the plot/outline of play"

» "Maria's case"—Maria was performing a constant circle movement with her hands; then she was moved from the left side of the screen to the right and she stopped moving; it was clear to me that she should be released—but how to release her when she had become such an important part of the image? She marked a horizontal line with her hands and she herself became vertical line—so the composition presented the junction of two basic lines: horizontal and vertical (cross); so again, how to release her and not hurt the image? Maybe Maria should be replaced with something? with a wooden stick maybe? Finally it happened, and traces of her performance and of her presence were left on the blackboard—a thick horizontal line was crossed by a thin vertical; so it was the proper moment to stop: exactly when the form was articulated.

» during the production of the second "answer" you as participants were asked to "not decorate" the image but to follow forms and make tectonic modifications of it; during these three exercises you (hopefully) learned how to "not decorate" and you became much more open to using an unknown language of art; so it had a double purpose—to find "answers" and learn certain skills; I can imagine that it's difficult to realize that you speak an unknown language without understanding its grammar, vocabulary, and so on; it's much more a prophecy-like situation than a rational one

» the third question was the most unclear. "Who is Carla?" is in fact ongoing research focused on two entities:

a. abstract one: "Carla"—type of artist from the typology of artists

b. living person: Carla—one of the workshop participants

» the difficulty is based on the unclear mix of these two entities; "Carla" has a specific creative strategy: surrounded by "frames" (time, material), looks for the "surprises" which become her artworks; it's a kind of strategy in which intuition works better because it's not disturbed by external factors; but there is also a play with material (images, movies and so on) itself in which there is an encoded message to be discovered and translated into an art message

» in case of the living person the answering process ("who is Carla?") is not reduced to the drawing session; when I proposed the exercise in the city (co-regulate/irregulate) Carla said that the proposal didn't fit the coordinates of her ordinary creative practice because it was not comfortable and was focused on direct social interaction/intervention (should we include this conditions to "Carla's" way of working?); Carla asked questions:

» how can I start asking more complex questions?
» how can I push myself out of my geometrical comfort zone?

It shows the ambivalence: she would like to go beyond her limits, but these limits are worth protecting (limits became a mental fence). "How to be a badass good artist?"

Badass good artists quite often work directly with social and political problems; they confront themselves with society, cross political boundaries, and do not expect comfortable working conditions; how to find out what is personal limitation and what is much more universal in this mix? What opens the stream of creativity and what is the obstacle? Should we call this mix of two personas equipped with contradictory habits and wishes an "art-education imbroglio"? How to teach art in such a case? How to learn art in such a case?

» I would like to make it much more abstract and talk about "Carla," but there is this dynamic of appearance in which certain declarations presented by "Carla" (I'd like to go beyond my limits) are confronted with contradictory expectations presented by Carla (I'd like to keep my limits); anyway I make it much more abstract here and I would like you to understand it as such.

» the question "Who is Carla?" somehow still is in the air—we were trying to embody this question, catch it in the frame of the typology, in the frame of the blackboard, but it seems to be much more alive and connected to real life; that's why it has not been answered yet—that's why the blackboard was not able to offer a precise answer, somehow the blackboard told us the truth and was honest; we realize who "Carla" is step by step; we opened the cognitive process and it goes on—or maybe Carla is using us to research herself;

» in the case of the black box and blackboard—that's the dynamic of being confronted with the circulation of elements in front of us (on the blackboard), which appear and disappear until they are fully articulated; it could be understood as a model of the creative process itself, as a cognitive game in which different elements (colors, forms, symbols, letters, and so on) are in a constant circulation—the blackboard was working as a screen of collective and individual subconscious; it's like in this Lacanian model of the subconscious in which it's structured as a language: rhetoric elements are in constant motion trying to find a way to the surface (a little bit like in a movie *The Cube*, in which hundreds of cubes are in constant circulation inside the BIG CUBE, and people imprisoned in them are looking for the way to the surface— and for the formula which organizes the movement of cubes; what we are looking for is a "bridge"—exactly like in the movie; https://www.youtube.com/watch?v=zN-Qps-g0g7g); such a Lacanian metaphor seems to describe the model created by us (blackboard exercise) very well: there are significant elements which appear ex nihilo on the blackboard and want to say something, want us to notice them, catch them, but they immediately disappear into the abyss of the black box; but sometimes they are noticed. In the case of the question "What is the source of Samara's images?" the word "TIME" appeared as a conclusion to the drawing process; that was the answer we were looking for—I would say that our model of the subconscious works (not in each case); maybe this model is a starting point to understand individual creative processes (and could help us to answer the question: how to teach the creative process?)

» there were three proposals which refer to this model (not on purpose) until now:

I. The Alchemist and their strategy: careful observation of social environment; emotional turbulences are a guideline for the artist in this process; internal map that offers the shortest (but difficult) way to the "conclusion", to the art formula that is able to modify the world; the artist is flooded by the wave of self and collective subconsciousness trying to swim in this ocean; the external world is included—it even plays the role of whisperer/prompter in the process; so this model represents a kind of extrovert approach to the issue;

II. "Carla": rationally created conditions to play the game with significant objects taken from the material world; a few controlled frames are used to create a social distance and silent zone for the intuitive game; external reality is excluded so as not to disturb the purity of the process, which seems to be a meditation/mediation in front of the changing forms; the clear message that the form/process is complete is a "surprise" feeling; so this model represents a kind of introvert approach towards the issue;

III. black box<>blackboard: the dynamic of the process has a bipolar nature—something appears then disappears; it's obvious that the process goes on but "nothing" is caught; blackbox<>blackboard describes an impulsive creative group process without leadership and without conclusions and with the deep feeling of insatiability; it's a productive process but it has to be analyzed to reach the conclusion; articulation of the conclusion also has a group nature—but then all elements of the process are elevated post factum to the rational level and elaborated there.

Fig. 120 Drawn note by Nastasia Louveau.

19.IV.18

»At the very center of attention«

sztuka polska

Artur Żmijewski

Face Painting—Individual Exercise #9

Face painting (photographs taken by Voigtländer and inspired by old photographs taken around 1910 in Australia which present ritual body painting by Aborigines)

Participants were asked to paint their faces with black and white cosmetic paint and take photograph of it. They could also ask the others to be a model. Ritual body painting by Australian Aborigines became an inspiration of the project. The old analogue cameras 9x12 cm were in use:
1. Voigtländer constructed in the early 20th century
2. Linhof Technika constructed in the mid-1970s.

The idea of the exercise was to "touch the body" and transform the body. And to cross the border of intimacy and make the image of yourself that is more honest about you than you could normally say. When the self-portrait or the portrait of the other (who became your alter-ego) is elevated onto metaphorical level because of painted face mask, body painting, and so on, you can safely tell us more about you. Much more than usually and in a more reliable way because what you say is quite unclear—the nature of metaphorical language is quite foggy. But anyway it's possible for the viewers or readers to know what the story is about. Many of the nice images made by the participants are about dignity and proudness. Also about beauty.

Fig. 121 Theory Development Sheet, detail in black and white.

Fig. 124–125 Proposal by Valentina Zingg: face-painting, involving her grandmother.

Fig. 126 Proposal by Carla Gabri: face-painting, involving her father.

139

Fig. 127 Proposal by Dimitrina Sevova: face-mask.

Fig. 128 Proposal by Wiktoria Furrer: face-mask, with ZHdK student Manoj Rajakumar.

Fig. 129–130 Proposal by Maria Ordóñez: face-mask with Artur.

Fig. 131 Proposal by Carla Gabri: face-mask with Artur.

Fig. 132 Proposal by Nastasia Louveau: face-mask.

Nastasia—(Subjective) Summary, May 28

Discussion was inspired by the short explanation by Nastasia. She declared herself unequipped with artistic ambition. She usually "doesn't know" what she does as an artist—when she makes art work (for example painting). Ambition is not her guide because it doesn't really works in her case—what she follows is craft.

But what is the reason to "lose" ambition? Maybe the geographical or geopolitical position of "Nastasia" (of Switzerland, in fact). Switzerland seems to be a province of Europe that transforms its provinciality into a value called isolation. It's a distanced country, isolated—art or cultural exchange suffers from it. But it gives artists in Switzerland this comfort of not really competing with the other artists. There is no significant difference between badass good artist in Zurich and conventional producers of artefacts. If the country is based on comfort, it's better to not ask questions that could hurt this feeling. In such a situation art should also co-produce this comfort feeling, and should even be made in comfort zones. It's maybe one of the reasons why there is this lack of ambition in "Nastasia." Nobody really expects you to be a badass good artist—or a political one. To become badass good would be a subversive act itself in Swiss society.

When you try to be political in Russia you can expect problems: prison, death, or expulsion. In Cuba quite similar: prison, forced emigration, expulsion. In Germany the strategy will be different: lack of reaction or overreaction by the conventional media, which will inform you that you are a Nazi or that you do not know German specificity. If you put a German brand in danger—for example, documenta—you will be investigated by the prosecutor. Switzerland is much smarter; it will stop you as an ambitious artist in advance. It will reduce your ambition to be political, to be badass good, or to compete with the others when you are teenager.

Trying to understand Swiss specificity, this equation was proposed:

Switzerland = safety
isolation = x

Where "x" is an artist without ambitions.

There was also a discussion about the cultural politics of the state—which is not interested in activating "what is hidden in the air, in the earth, in the body." But this is a task for art-teaching—to let people (art students, artists) have open access to all possible mysteries/horrors/treasures hidden/closed/blocked in the air, earth, body. You have to be so sensitive to find what is hidden in all these "places." The task of the teacher is to support your sensitivity—we could even say "selective sensitivity."

So, one of the most difficult exercises for the students would be to find out "what is hidden in the air, in the earth, in the body." Depression, illness, meditation, and so on could help in such a artistic research.

There was a discussion about the sensitivity of the artist—the metaphor of radio waves was used. There are dozens of transmissions that go on but nobody can really hear—so the method to hear would be to "adjust the frequency." Let's say that the victims of the past still transmit their pain—or the earth itself transmits voices of the people whose bones lie there (former war zones in France and their trenches still carry remains of the 1st World War battles). Our goal as listeners/artists is to find a proper frequency and adjust the volume upwards.

It reminds me of a very interesting story that I found in a book by Bert Hellinger or by Milton Erickson. There was a young female doctor—she was working with corpses of dead people in a morgue, doing autopsies. She did not like this work (who would like it?), but she was not able to stop—something forced her to continue. So she was busy with her job and with the misery of her life. She had a psychotherapy because this job made her depressed and at the same time she felt addicted to it. Once she told her therapist about a strange practice carried out by her father every day. This old guy spent hours lying naked on the floor at home (without shame). It was not a strange sexual practice; it was a passive activity performed by him every day. She was asked to dig into this a little bit—we should be aware that her father did not talk about his past too much. So she started to investigate his motivations. When he stopped being mute she realized that her father had been a member of a so-called *Sonderkommando* in a Nazi *Vernichtungslager*, where he cleaned the gas chambers and transported people's corpses to the crematorium. At the very end of his life this was transformed by him into that kind of necro-performance developed and practiced every day. Then she realized why she worked as a cold-surgeon cutting dead corpses. She was a victim of the past even if her father was trying to protect her and did not share his secret with the family. But she was somehow exposed to this radiation—to something that has no taste, no smell; you cannot hear or see it. But this hidden factor decided about her life. This example shows how in her case the feeling of depression came from outside—she was colonized by foreign depression, foreign disease, foreign memory.

The story has a happy ending—she changed her life and became a pediatrist. She became healthy and forgot about depression.

Of course we are not interested in happy ends; we would rather ask the question of how to continue work with "dead issues" and at the same time be aware of where the roots of each "dead corpse" are.

This is very much like a part of the text by Freud in which he talks about the psychologists and psychotherapists (like him) who are aware of their deeply hidden psychological processes on purpose—because that's the substance of their work/research/therapy. I would compare it with artistic practice.

Following Freud we could say that the life of the aforementioned cold-surgeon was determined by invisible/non-controlled factors. There was a hidden intelligence that forced her to follow her father's track—and to discover it in a certain moment and

then to emancipate herself (maybe it's a destiny of artistic practice in general). But that's exactly what we are looking for—all these hidden tracks which define society, political life, the shape of our countries, and our individual fate. All possible symptoms that occupy our bodies and psychic life—which look like illness, strain, trauma, or moral devastation and so on—they are our brutal friends. They show us the track and whisper, whisper, and whisper when (in which moment) we should find a way to the surface (consciousness).

As a final part we discussed models of creative process that had already been proposed:

» the Alchemist
» "Carla"
» black box–blackboard

The Lacanian model seems to be effective in order to understand how the process is developed: according to Lacan the subconscious is structured like a language. So it's composed out of rhetorical elements (letters, words, symbols, numbers, shapes, and so on) in constant motion. All this process is hidden within the subconscious—but sometimes these elements/pieces elevate themselves / are elevated onto the conscious level. Then WE KNOW; we realize what the story is about. It's probably a situation in which not one element is transferred from the hidden zone to the visible one, but the constellations of elements travel from one level to another—formulating significant or readable shapes during their journey.

I read an interview with the Polish artist Jakub Julian Ziółkowski recently—he is a painter. He declared in the interview (https://magazynszum.pl/nachapacze-i-apacze-rozmowa-z-jakub.../): "[...] the artist goes to the 'unknown,' following the request of intuition. It is not known what will be the outcome, but it must bring a move. It is almost impossible to know what you want—there is only a call from your inside. This request/call cannot be really defined, it is like a call coming from roots, from something what you always had inside"; "[...] you have something in you, but you don't know what it is and where, you only know that it exists because you hear a call. It follows you and screams louder and louder, you'd like to get it out, but you cannot catch it. You have to research yourself and make a magic step/move to catch this 'thing.' But when you do this, you don't really know how it was possible"; "[...] creativity is a time of total synchronization with yourself. Things that are usually inaccessible, deeply hidden, go to the surface. I only transmit those things like a medium."

We seem to be here in the presence of an alchemical text—very unclear, mystic, "written" by someone who is lost in mind, in the body, in own fantasies. But is it really so undefined? Is Ziółkowski busy with all possible human topics to make art out of it? No, he represents a specific genre—a kind of "fairy tale" painting, presenting fantasy

objects, a little bit obscene, colorful. I would say that he is able to catch only those elements which can be somehow recognized by him (defined by him) as significant and which could be transformed by him into the "bricks" of his limited story. That's the moment where the individuality of the artist (individual limits) meets the social request formulated as "do something." Anyway, Ziółkowski doesn't need a teacher—but the others do need one (me, for example). Should we be focused on those who need a teacher?

To not-conclude: there is a selection mechanism or even mechanisms which let artists select one /a few /very few elements from the circulation of all possible rhetoric elements and make an artwork out of it. It means that—unlike in the Lacanian model—a selected element is not elevated to a conscious level but is kept on a half-conscious, half-subconscious level, because art is not a rational discourse.

Artur

Nastasia Louveau
May 30, 2018

Diary of *affect*: your summary makes me FURIOUS! (The part concerning my explanation, that is.) I will try and be more precise at a later time—but for now I'll keep it short: I guess this anger has to do with (a) not agreeing with you on your interpretation of the terms and of my statement, (b) realizing I might have meant something quite different, and I want to change and find new terms that reflect my practice more accurately, and (c) still, it might affect me so much because it does touch a sore point.

Nastasia Louveau
That's the good thing about diaries and writing down affect—I like its power = now that I have somehow, by the act of writing away, emptied my body of the interfering emotions (that really are bodily phenomena), when I re-read your summary I can actually focus on what you wrote, Artur, and not on the emotions it triggered earlier. And thus the need for new terms will probably be minimal—because we do agree to a certain extent. (to be continued ...)

Artur Żmijewski
I should write "Nastasia" in quotation marks to make obvious that the discussion and comments were perhaps inspired by individual experience but pretend to describe a wider situation (as in the case of Carla–"Carla"); this summary is "very subjective." Since the notes we take during these discussions are drawings, many thoughts are lost on the way, misunderstandings are possible.

Carla Gabrí
Artur, your thoughts about this young female doctor and Julian Ziółkowski are very interesting. Just for clarification, what do you mean by this sentence in the end: "That's the moment where the individuality of the artist (individual limits) meets the social request formulated as 'do something.'"? And why do you think he doesn't need a teacher?

Artur Żmijewski
The artistic career of Jakub Julian Ziółkowski began very early—he was obsessively painting and drawing already in primary school. He also said in the interview that it's impossible to teach painting. That's why I wrote "he doesn't need a teacher."
"That's the moment where the individuality of the artist (individual limits) meets the social request formulated as 'do something'"—it's a difficult moment, not really developed. I would say that a social request, or even a demand (in the form of formulated or un-formulated questions/orders) meets the individual artist who could possibly follow it and fulfill the request/demand/order. So to follow the request such a person has to be sensitive enough to read the request and weak enough or their self defense / immune system has to be somehow disabled. Disabled enough not to

protect them from following external demands, to let these issues occupy them. The artist behaves like a filter—they filter these rhetoric elements coming from the subconscious—and create only such constellations which are possible because of certain configuration of the filter.

It's a little bit like with politicians—they are in a constant selection process, choosing from the whole spectrum of political views, expectations, fears, wishes, and so on just those that confirm their political position. The politician also has a specific filter that constantly works—operating exactly in this "Lacanian sphere" where rhetoric elements circulate. But in the case of the politician all rhetoric elements have a political label. So it's much easier to select them properly.

In art it seems to be more difficult—for example, if you want to create paradoxical artwork, you need to select only these elements that have a potential for paradox. Or just the elements that are paradox-free, but when combined and transformed into an art work they create a paradoxical effect.

It has to be ordinary practice in art, where "questions without answers are a matrix for questions, or the matrix for answers is paradox."

Okay, but how does this artist-filter work, and what does education mean if we understand the artist as a filter? Maybe education is a calibration process—as in case of monitors or radars, which need to be well calibrated to show/screen images properly or to find expected objects that are hidden somewhere in the air (in the earth, in the body).

I would say that the radar of Jakub Julian Ziółkowski has a narrow angle—only those fairy-tale-like figures can be observed by his radar. Anyway, he is one of the most successful Polish artists (his works are much appreciated by collectors. So it seems to be okay to educate artists as follows: the teacher calibrates the radar of the student to make it over-selective. Ziółkowski seems to be locked in his specific genre, but he loves this "prison"—collectors and the art world also love his cell.

So let's equip all types of artists from our typology with specific types of filters—meaning let's start developing a "typology of filters."

What's the filter of Samara? Samara seems not to be able to manipulate groups of elements that come from the "rhetorical sphere"—she is able to select only those "images" that have a complete form/shape; she selects such elements and prints them—that's her job.

What's the filter of "Carla"? "Carla" is able to select groups of elements and "negotiate" their constellations.

What's the filter of the Desperado? Probably very much focused on subtle issues, fragile points which belong to the others—let's say "buttons" that could provoke reaction when pushed.

What's the filter of the Lifestyle Researcher? Probably this filter selects only the elements that would resist being transformed into "real" art. Perhaps the Artisan has a similar filter.

ART AS PROSTHE

ARTIFICIAL LI

PROSTHETIC LIMB

Artur Żmijewski

Study of the Human Body—Individual Exercise #10

Study of the human body (with use of analogue 16-mm Bolex camera)

Participants were asked to make a short movie about the body of an old person. We established a partnership with a home for elderly people located close to Klusplatz in Zurich. The idea of the exercise was to reduce distance to, let's say, mortal questions. Students were busy with the very old (and very exhausted) issue of the "study of the human body," very academic and very very old. But at the same time they were studying human mortality, the finiteness of the body, the slow destruction of skin and other body parts. So real artistic issues were at the core of this exercise—turning from a mere school setting to art and pure human problems. Participants were exposed to the brutality of biological destruction and social exclusion (in its soft forms: home for elderly people).

Here a comment by Nastasia Louveau: "I didn't follow the imposed rules for this exercise and did not film an old person from the Klusplatz home for elderly people, instead I did a study of a pregnant friend's body in the park of the Klusplatz home, as a reaction to the obsession with death, mortality, structural violence, and bodily decline that I felt was infusing the workshops (as it infuses Artur's work). I first asked my 80-year-old neighbor, Frida, who is blind and has lost eyesight over the past decades, but as she politely declined I couldn't help feeling like a voyeur and a cynic and decided to ask a pregnant friend very close to giving birth if she would accept being the subject of this 16-mm 'home movie'."

Fig. 133–134 Theory Development Sheet, detail in black and white.

154

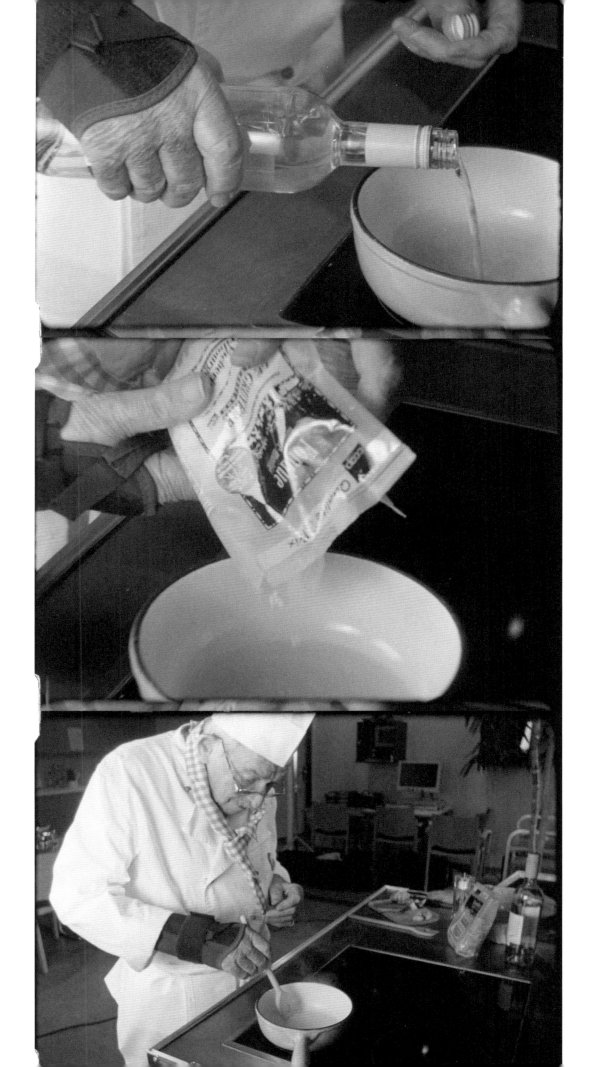

Fig. 135–140 Proposal by Carla Gabrí: study of the human body.

155

Fig. 141-144 Proposal by Valentina Zingg: study of the human body.

Fig. 145 Proposal by Nastasia Louveau: study of the pregnant body.

Artur Żmijewski

What's in the Air, Earth, Body?—Individual Exercise #11

It's probably the most difficult exercise, and is focused on mystery itself—on the deepest connections between bodies/minds/personalities and ghosts who exist in the earth and in the air—living and dead entities that have no bodies but influence our life; the goal of the exercise is to realize that art can be a cognitive method that uses an alternative language of images, intuitions, practices, and rituals—that is able to create entities and facts equipped with persuasive power.

Fig. 146 Theory Development Sheet, detail in black and white.

Fig. 147 Proposal by Maria Ordóñez: what's in the body? biopoetics, DIY microscopy, videostills.

Fig. 148–153 Proposal by Carla Gabrí: what's in the body? atopic skin, still photograph, developed by hand in vit. C, washing soda, and coffee.

Fig. 154–158 Proposal by Carla Gabrí: what's in the body? atopic skin, still photograph, developed by hand in vit. C, washing soda, and coffee.

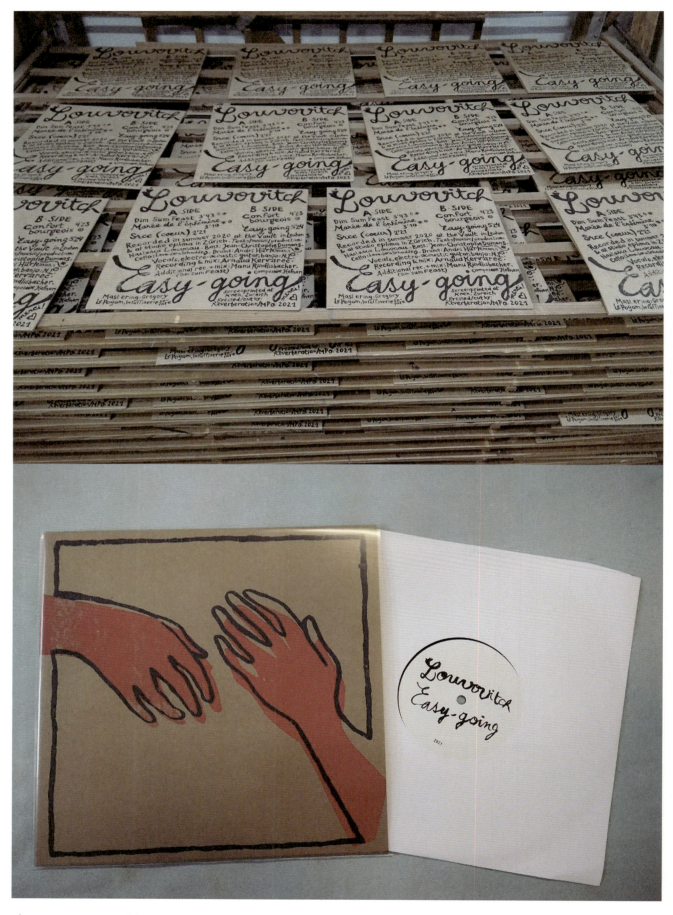

Fig. 159–160 Proposal by Nastasia Louveau. what's in the body? Louvovitch's first album Easy-going.

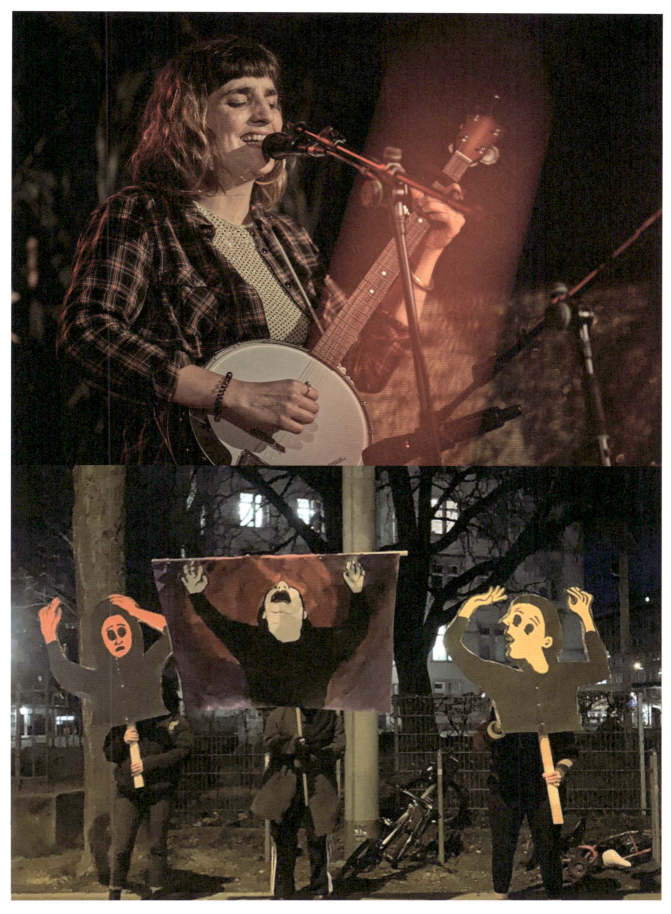

Fig. 161 Performing and voicing grief. Louvovitch concert, June 2020.
Fig. 162 Klageweiber figures (mourners) at Ni Una Menos protest in March 2021, Zurich.

**Wiktoria Furrer, Carla Gabrí,
Nastasia Louveau, Maria Ordóñez**

**Moments of Controversies, Crisis, and Creation.
Looking Back on *How to Teach Art*?**

Fig. 163 Theory Development Sheet, detail in black and white.

Wiktoria Furrer

Art of Pedagogy

The workshops not only raised the question of how art can be taught but was also itself a collective exercise in how to teach art in practice—with an open, unforeseeable result[1]. We as participants were deeply involved in an intense artistic process that ranged from April to August 2018, including long working meetings twice a week that often extended into the late evening hours.[2]

The art of pedagogy of this process originated from the exercises that Artur Żmijewski proposed as well as our answers and reactions to it. In spite of the didactic structure that he created by setting topics and tasks, I found myself more in a shared—yet not safe—space of experience than a linear mediation of knowledge. In this reflection I want to follow traces of the specific art of pedagogy as I experienced it as a participant, and go into the matter how the process of collective and artistic actions was facilitated: how did the experiential space come into being and how was it engendered by all of us in the workshops?

Controversy and critique

The workshops were accompanied by some controversies. Starting with about 20–30 attendees and gaining a lot of interest at the Zurich University of the Arts, after a short time the number of participants shrank to a small group. Many art students left the workshops after presenting their artwork during the first session of three days. The remaining core group, complemented by some spontaneous guests, consisted of Carla Gabrí, Ekaterina Kurilova, Nastasia Louveau, Maria Ordóñez, Dimitrina Sevova, Nika Timashkova, Valentina Zingg, and me. Some of us were doctoral students at the Epistemologies of Aesthetic Practices program at the Collegium Helveticum. Many pursued an artistic or curatorial practice of their own beside their academic work or were trained artists. All were women in their twenties and early thirties. I can only speculate that it was this asymmetrical situation—with Artur Żmijewski, the internationally acclaimed artist, often discussed for his provocative art on one side, and young women at the beginning of their vocational path on the other—that provoked a lot of the criticism, that we as participants faced from some colleagues at our respective universities, in academic settings, and more informal meetings. Those voices insinuated Żmijewski as an authoritarian figure, some kind of an artist-father who imposes his power upon naïve, defenseless students. Nothing could further from the complex group dynamic than this simple fantasy. A stereotypical fantasy as well. I find it paternalistic to imply that we were seducible women, unaware of what we were signing up for.

Obviously it was Artur Żmijewski's sharp, controversial position as an artist, in opposition to what was later typologized as the "mute teacher," that attracted critical

attention (compare with Artur Żmijewski's typology of artists and teachers, pp. 14–15, 27–28 and 49–50). Interestingly, the criticism sheds light on the fundamental paradox of pedagogy, which repeatedly insists on divisions between teaching and learning as well as a hierarchy between teacher and student while claiming the student's self-determination. In this sense the initial question of how to teach art led to a subsequent question: how to act in an imbalanced situation, without adhering to roles, beforehand molded as paradigmatic by others? I would argue that the encounter between Żmijewski and us was renegotiated in different situations during the workshops in a process of defining authority and claiming self-assertion and self-determination by the participants. In my perspective what set the tone for the whole duration of the workshops was that Żmijewski presented himself as a vulnerable teacher. And this, as an aftereffect, involuntarily forced us to become vulnerable ourselves.

Vulnerable teacher, vulnerable participants
On the first days of the workshops we talked about what we are currently working on and what we are interested in. Artur Żmijewski started by telling us the story of how he had recently worked on a project in Moscow[3]. He vividly described how he lived in an ugly, claustrophobic public-housing flat. He told us about getting sick again and again and walking erratically in the monstrous city, looking for something in the surroundings that could become his trigger or topic of a work on the state of contemporary Russia. Instead he was confronted with emptiness. He realized that creative processes became more and more accompanied by depressive phases. As if he had lost some immunity against the evil and ugliness of the world that he felt he was equipped with earlier, when he started as a young artist.

I was moved by this unsparing narration of his dark experience. His urgent and compelling mode of address caught me unprepared, because I was—even in art school—trained in academic discussions on an abstract level that tend to avoid personal abysms. But here he did not present himself as a successful artist, and instead showed himself to us unfiltered as though damaged and worn out by the artistic process. Artur Żmijewski's self-narration was fragile, and ours became fragile too. The unsparing way in which Żmijewski spoke of himself co-defined how we were going to relate to each other. This first encounter in April determined the tone of the workshops as a whole. It forced us to become vulnerable and sensitive to inner processes as well. It seemed as though we made a pact to speak with radical honesty for the duration of the workshops.

One day Carla Gabrí and I were working in the darkroom developing photographs we had shot with the Voigtländer camera. We were absorbed by the photographic processing, concentrating on following the exact order while dipping the plates first in the developer bath, then the stop bath and fixer bath, knowing that one wrong move would irreversibly destroy the image on the negative. Complete darkness surrounded us like black cotton wool. Without being able to see each other, our hands tried to coordinate themselves clumsily. Only our voices, counting the seconds the photographs were soaked in the chemicals, gave a hint of our position in the room. After a while, our movements became smoother and our bodies less tensed. The

choreography of developing became practiced. The darkroom was like a Faraday cage that hermetically shielded us from the outside world. In this intimate space we started talking about our families, childhood, and relations. Telling stories not often told before, painful and shameful. The darkness protected us from judgment. Similarly the workshops were a zone shielded from the routines of everyday life, where bonds and relations between us women grew in an accelerated way. The workshops became a darkroom for processing relations with ourselves and others.

Artur Żmijewski's story at the beginning of the workshops not only changed the way we represented ourselves, it also narrowed down the topic of the workshops, as it problematized the initiation, control, and side effects of artistic processes: What is needed to get an artistic process going, for an artist to remain vulnerable without being exposed? The next controversy arose in this context as a protest against the psychiatric vocabulary that Artur Żmijewski used in his description of artistic crisis: depression, neuroticism, mania. It reminded some of the participants of the myth of the "suffering artist." Carla Gabrí called those metaphors a manifestation of an "excessive dependence on pathological terminology."[4] Nastasia Louveau pointed out that it was problematic to reproduce a psychiatric discourse that has a normative power to divide people according to clinical diagnosis, writing the following: "I would rather subscribe to a radical anti-psychiatric view in which these facets of personalities all belong to the spectrum of human life and emotions. In this view it is the psychiatric institution that creates the tangible profile of the Neurotic, the Schizophrenic, the Depressed and that marks him or her as ill, creating a foil (the diagnosis), a social role and function with which the person identifies, thus becoming ill."[5]

This discussion on terminology clarified what the main problem was that we wanted to tackle together in the workshops. We also realized that how we speak defines the object we speak about—since the aim of teaching art, according to Żmijewski, was to radicalize subjectivity, as artists should articulate themselves in society and participate in social processes through their work. Intuition is the proper tool of art. Intuition is a key to the world and brings to light insights that would otherwise remain hidden. Art creates knowledge of the self and the world, though in a sometimes agonizingly incomplete way.

For me the five months of our collaboration were indeed an intense examination of how I can integrate a more intuitive approach to my work. Intuition was exactly the force I usually omitted before. Even though I had a strong interest in alternate configurations of knowledge, I was ruled by an epistemic regime of linearity, universality, and causality. The uncontrollable, often fugitive process of making art together taught me better: not knowing, feeling lost, and practicing new things like analogue photography or video editing often left me helpless and clueless. A state where a comfortable lining made out of arguments and theories did not help much. While drawing together I experienced moments of play and spontaneity, where forms just emerged on the sheet without being designed. During the workshops I had no other

choice than to surrender to a creative process, even if it often seemed untransparent to me. Being repeatedly immersed with others in creative actions made my perception more porous, because it demanded constant attention to my surroundings and co-participants. Similarly to singing in a choir, I learned to become more attentive. My rational armor softened. Being in tune and in flow allowed intuition to work. The mode of speaking and sharing one's thoughts and feelings, as well as engaging with intuition, became the common ground, a specific "affective infrastructure" of the workshops.[6] The affective infrastructure is the way the space is held, how everybody involved facilitates the possible. In *How to Teach Art* the vulnerable teacher brought along an infrastructure of vulnerability.

Collective mind

The didactic structure of the workshops consisted in individual and collective exercises. In our sessions we either worked individually on exercises that Artur Żmijewski had assigned to us or as a group in painting/writing on a paper roll on the floor (Theory Development Sheet) and on a huge blackboard (Blackboard Conversations), engaging in actions with objects and playing with blocks (for images compare with the "Visual Discussions—Collective Thinking" section in this book). The intuitive approach impressively left its mark on us during the collective exercises. Intuitive action was not an individual practice; it was something that showed in the tentative reactions during visual games that took place on the sheet or on the blackboard between all the participants. Whereas one can adhere to the illusion of keeping one's own actions under control, in collective artistic actions the density of events, crossings, and accidents shows that this is not possible anymore.

Maria Ordóñez described the Theory Development Sheet (a large roll of paper made of six sheets of drawing paper taped together, see fig. 80 on pp. 100–101) as both a stage and a mobile archive that accompanied us on our repeated journeys back and forth between workshop venues at the Zurich University of the Arts and the off-space Corner College, run by participant Dimitrina Sevova, where many of our discussions took place.[7] While discussing, we drew and wrote on the paper, noting our thoughts and questions, or simply scribbling on it. As the speaker's thoughts were visually captured and noted, the next person could continue, questioning or negating them. In the next meeting, regardless of who was present, the discussion kept going and the collective flow was not interrupted. Everything served as a vehicle for further discussion. It was remarkable how the Theory Development Sheet generated two modes of thinking—one visual, one discursive—that started to co-exist in the workshops. We overpainted and overwrote the paper until it became unreadable and almost fell apart. It contained layers of drawings and scribbling. During collective actions, not the individual and her artistic choices were in the focus, but the collective development of the work. What filled the Theory Development Sheet did not belong to one author. This forced us to concentrate on what we produced and not on the demarcation of individual contributions. Modalities of collective thinking and the redistribution of roles were striking features of our collective works. They became visible in the Blackboard Conversations and on the Theory Development Sheet—physical manifestations of our theoretical discussions. This collective work-

ing mode stems from the didactic tradition of Grzegorz Kowalski, Artur Żmijewski's professor at the Warsaw Academy of the Arts, in whose studio, called Kowalnia, he graduated. Professor Kowalski developed the pedagogy of partnership, and in his famous exercise *Obszar Wspólny, Obszar Własny* fostered collective artistic actions.[8] His approach was very influential on many critical Polish artists such as Artur Żmijewski and Paweł Althamer, who applied Kowalski's teaching methods in their art projects and participative workshops. Many of the exercises, such as Face Mask, developed by another professor, Wiktor Gutt, had their origins in the pedagogies in the tradition of Oskar Hansen, Jerzy Jarnuszkiewicz, Grzegorz Kowalski, and Wiktor Gutt at the Warsaw Academy of the Arts. Common to them was the understanding of art as a language and a means of communication in society. Art is a language that can be learned and that de/codes the visual environment as well as makes it readable for others. Art is able to encompass dialogue in society on many levels. In the Blackboard Conversations we experienced how art can indeed mediate and configure unique experiences and insights. In a series of Blackboard Conversations we answered questions on a huge blackboard in a top-lit room. Our first question was about the origins of the images: where do images that fill the mind of an artist come from? In an impulse that I cannot properly understand myself, I put on a black T-shirt and trousers that somebody had left in the painting room—a painter's uniform that surprisingly fit perfectly. It was a first superficial step of metamorphosis that helped me to prepare for drawing on the blackboard. The change of my appearance silenced my inner censor. When I see myself on the videos I do in fact recognize myself, but at the same time I see a stranger who is absorbed in drawing. In the beginning of the session we were a bit lost. But soon we stopped talking and started drawing symbols, forms, and words. Furthermore, the blackboard became the background for performative actions. As we started to interact with each other the blackboard transformed into an intimate stage without viewers. The next time we brought skeletons into play that we found in the drawing room. Everybody seemed to be submerged in a collective mind.

Pedagogies of crisis

The dramaturgy of the workshops was quite steep, like "a film that begins with an earthquake and works up to a climax."[9] It started with disturbing images of the Holocaust, and ended in 16-mm filming of elderly, very fragile people in the Alterszentrum Kluspark.[10] One person portrayed, Ernst Bärtschi, who was 100 years old, died shortly after finishing the video production. Maria Ordóñez and I, who spent a day filming him, were disturbed about his death when we heard about it. Herr Bärtschi had told us that he had filmed his family all his life, even with a similar 16-mm camera to the one we used, but had never been filmed himself. At the very end of his life, we witnessed and documented almost his last moments and portrayed him on 16mm (the exercise was called Study of the Human Body). Afterwards I felt kind of guilty and ashamed to possess such delicate material, the last trace of a human life that I somehow became unpleasantly responsible for without asking for it. Not being an artist, I had no artistic justification for myself, only an itching conscience.

For the first individual exercise— "using abstract forms and maximum five colors (white, black, grey, red, and blue), deny and confirm the image"—Żmijewski presented us with disturbing photographs from the First and Second World Wars. But was this move only a form of provocation, with the single purpose of shocking the participants? In my eyes the exercises were intended to loosen our usual thinking patterns. I think that the snippets of images and newspapers that Artur brought with him, depicting war and pathologies of the human body, confronted us with violence, pain, and human cruelty. They fundamentally forced us to channel our attention to existential darkness and tragedy. I understand this approach as a confrontational didactic, a pedagogy that induces confrontation or conflict in some form. A pedagogy of crisis that demanded answers from us. At some point many of us experienced a crisis that became a turning point. Those turning points were evoked by the didactics of the exercise, but happened in an unpredictable way and on their own terms.

Nastasia Louveau, for instance, vehemently resisted the insistence on dark topics like death, history, transience, which Żmijewski regarded as being particularly urgent for artists. She refused to partake in his obsessive engagement with difficult themes such as disease and depression. Going against the theme of the Study of the Body (of elderly people) exercise, Nastasia Louveau was the only participant to film a pregnant friend rather than someone old and sick in the retirement home. The contrast between the promise of new life and the fading of life, the sheer opposition of life and death, could not be made clearer. By doing so she defended her own alternative artistic practice, where she focuses on her inner world and personal relationships, her family, and friends. As a gesture of care and conviviality this practice is no less socially relevant.

Another turning point was the experience of Carla Gabrí, who put her own artistic method at the center of our discussions. As Artur Żmijewski described it in his introduction, Carla became a "case" and "artist type" in the typology of artists that we developed together at the beginning of the workshops. I want to recall a different moment, where she distanced herself from the demanding exercises by dismantling the power constellations of the workshops in her pictures. For the exercise Face Mask, inspired by aboriginal ritual face-painting, Carla Gabrí had Żmijewski paint and then photograph her own face in the most radical form of face painting: blackface (see fig. 131 on p. 143 in this book). The use of the analogue camera, a 100-year-old Voigtländer that was used during colonial wars and exploitation, was a reminder of 20th-century colonial oppression and images politics, where indigenous people were depicted in a devaluating way. Gabrí's image not only points out the witnessing and complicity in this problematic form of face-painting; it also exposes Żmijewski's authority through gesture, since she had him release the shutter. She asked Maria Ordóñez to photograph the whole scene that she has created.

I myself had doubts about my role in the artistic processes. As a researcher working with media workshops, collective readings, and performative elements in the field of

art and art education, photographing, painting, or filming are not part of my everyday practice. I write and think about these things, and facilitate creative workshops on different topics, so they are familiar to my mind but strange to my hands and body. Being part of the workshops brought home to me how different these working modes are. While video-editing my 16-mm film, I had no clue about how to arrange sequences of the video material. My choices seemed random to me, not following any purposeful logic or creating in any form a narrative, whereas Żmijewski patiently played around with video snippets that almost magically found their convincing order. In contrast, while writing—for instance these sentences—I deal playfully and fearlessly with text fragments and unfinished thoughts, and rearrange them intuitively, until they tell a more or less comprehensive story. With my lack of artistic skills and craftsmanship I would see myself as an extreme case for the question of how to teach art. Astonishingly my inability in different artistic practices did not hinder me in becoming deeply involved and eager to learn. Unforgotten to me is a series of lucid and symbolic dreams, during the time of the workshops, where I transformed into different artist figures, a musician, composer, and writer, creating the most beautiful sounds and poetry. I am only unsure if it was exactly *art* that I was learning about, or rather myself. I grasped the shades of the artistic process. My ideas, fantasies, even dreams circled endlessly around the progressive filling-up of the Theory Development Sheet and the blackboard in the top-lit room. It was difficult for me to endure this ambiguous state of work in progress, surrounded by enigmatic blackboards, where I was confronted with inconclusive results. Afterwards the state of vulnerability and porousness became the central resource in writing my thesis. Under the lasting impression of the radical mode of articulating oneself, I began writing from a far more subjective standpoint, acknowledging blind and dark spots in my thinking as productive sources.

What is common to these descriptions of experiences is that they reveal how pedagogies of crisis are effective in depth without being strategically applied by the artist. It was the interplay of the didactic structure and the affective infrastructure, the ensemble of Artur and the participants as well as the ecology of media and material that created the art of pedagogy.

Art of pedagogy
Almost three years have past since we met in Artur Żmijewski's workshops. The exhibition *How to Teach Art*, in which Artur invited us to participate, at the Kunsthalle Zurich in the framework of *100 Ways of Thinking*, curated by Katharina Weikl and Daniel Baumann, was not the final culmination point of the workshops.[11] The influence of this extraordinary experience is lasting. Some of us reordered the relation between our academic and artistic roles. Carla Gabrí, Maria Ordóñez, Nastasia Louveau, and Nika Timashkova continued their artistic work, gained new impulses for their artistic practices and struck new paths. Many exhibitions and concerts followed the workshops—not accidentally, I think. My writing has changed. I am convinced that the specific affective infrastructure of the workshops and the position of Żmijewski

as a vulnerable teacher shaped the relations and tone of our time together. In connection with this, the confrontation with difficult topics and the crises it evoked made us rethink and reshuffle our positions. Resistance and conflicts became artistic means of productivity. Also the collective working mode, which was new to us and had not been taught to us at the art academy or universities, sharpened our sensitivities and made space for an intuitive approach. New areas in ourselves became accessible. How to teach art at once meant how to navigate dark inner spaces as we once explored the darkroom of the photolab.

Carla Gabrí

Who Am I?

I joined Artur Żmijewski's workshops on *How to Teach Art* while writing a dissertation on textiles in the moving image and gestures of *re-formatting as resistance*. As a member of the research project *Exhibiting Film: Challenges of Format*, led by Prof. Dr. Fabienne Liptay in the Department of Film Studies at the University of Zurich, I already had a strong affinity with formats and the way they are inevitably linked to power relations and knowledge orders in real space.[12] I was also aware of Żmijewski's artistic practice and the specific way he uses formats to evoke or to (re)create specific conditions that would sometimes violently act upon the people he is working with.[13] Lastly, I was also fully aware that I would automatically and silently agree upon acting within any format he would impose on me as a participant by joining the workshops. At least that's what I expected based on Żmijewski's reputation.

I was therefore reluctant to join. Although I respected Żmijewski as a contemporary artist and closely followed his work, I would probably have preferred neither to meet him in person nor face the possibility of becoming a subject of his artistic work. I felt comfortable with my usual position as an academic who observes and describes the power of formats from a supposedly outside perspective (although this, of course, never holds true). I also felt comfortable following an artistic practice that unfolds inside my art studio, dealing primarily with aesthetic issues I might find interesting but not too difficult to handle. But getting the opportunity to work with Artur was also a no-brainer, and I joined anyway—how could I not.

To a certain degree, my workshop experience is already conveyed through the artworks I created and submitted throughout the workshops, artworks spread throughout this publication. Nevertheless, I want to highlight three key moments that proved to be of uttermost importance for me as an artist, scholar, and ultimately, as a human being.

"Carla": artist type number 9 (or was it 10?)

The first one circles around the session of May 14, in which we collectively discussed my approach to artmaking—a topic that arose out of my personal resentment of Żmijewski's typology of artists (see pp. 14–15, 27–28 and 49–50). While listening to Żmijewski's explanation of the typology, I felt I was encountering a prime example of a violent formatting process, disguised but maybe even genuinely meant as a tool for easier communication. Żmijewski suggested we work with a typology he created, but also imposed it on us participants. The typology became a central discussion topic, one we could not avoid, and informed much of our thinking about art-making. For weeks he made us discuss the nuances between the different stereotypes of artists, which inevitably lead to self-reflecting moments in which we started to identify with some of the types he created. Am I an Idiot, or am I a Calculator Woman? Can I be a Shaman, although there is nothing even remotely shamanistic about my Swiss,

uptight upbringing or rational way of thinking about the world? Maybe I'm just a Lifestyle Researcher. Maybe my art practice contains aspects of every single type, or maybe—and that's where I settled—I am none of them, simply because I refuse to be something Artur can summarize in a catchphrase.

Looking back, I guess Żmijewski felt my need to position myself outside his framework—my need to *re-format this format*. That might be why he invited me to define my very own artistic practice by using my own words. Throughout a four-hour session, I described and visualized the way I encounter art-making, as something I approach in an analytical and highly controlled, at times even distinctly compulsive way, only to find a space or rather a minute of free intuition in which I can access art-making in its purest form—freed from any rational thinking, led by nothing but my hands—the only minute I would ever find relief from my brain. When Artur asked me how to name this type of artist, I bluntly replied, "Carla." When he then summarized the session the next day and described the new artist type "Carla," I juxtaposed his summary immediately with a summary of my own, willing to further claim back agency through re-formatting any type of format proposed by Żmijewski, even if it came in the form of a simple summary (see pp. 66–69).

However, "Carla" inevitably became just another type in the list of typologies, and ended up being labeled as number 9—or 10 (at this point, I am not even sure anymore). The dilemma was, however, that my desire to claim back agency through negating the typology unfolded itself within the very framework of the typology. I might have used "Carla" to pinpoint the lack of accuracy and subtlety of the other types, which were the result of a top-down rather than a bottom-up process and felt reducing, at times even violent towards any notion of agency and self-proclaimed identity. But I found "Carla" only because of the confrontation with the other types. The only reason I even looked out for "Carla" was because I set my artistic practice in relation to everything that Żmijewski already described. Hence the only way of truly addressing the issues I had with Żmijewski's authority required me to become a part of the very thing I wanted to address. The only other option to express my attitude would have been to withdraw myself completely and leave the workshops. A few of the other participants did, albeit for various reasons and at different stages. But their departure ceased to meaningfully impact the workshops or the discussions held, so I never considered this an option interesting enough. Instead, I committed myself to the dilemma of being part of what I was criticizing.

As a side note, I observed and struggled with the same apparent contradiction as a film scholar when writing and reflecting about contemporary artists who perform institutional critique while working within institutions; artists who would challenge historiographic canonization through writing history, or attempt to deconstruct the museum and the exhibition as a format while showing their work within these very formats, simply because outside of it they would either lack visibility, accessibility, or any kind of reference or relevance. These artists might be pushing boundaries, but they seldom overstep, dissolve, or fully break them, which makes it somewhat difficult to value their critique in the first place. Prior to the workshops, I didn't really know what to think of this. But to paraphrase visual artist Carey Young and her *Notes*

from the Inside, there might be no "outside" position from which to protest, only an endless 'inside.' The experience I had throughout the workshops made me embrace this constant self-entanglement and value the attempt to redefine the given as one that might always be bound to fail but nevertheless carries the potential of making things visible, hence negotiable, that weren't negotiable before. Maybe that's all you can do.

Who is "Carla"?
The second crucial moment for me is closely linked to the first one because it concerns one of the collective blackboard exercises we did a week after the aforementioned session on "Carla." As Maria Ordóñez describes in her own reflection (see p. 192 sq.), the collective exercises were pivotal for communicating and finding access to a collective thinking that wasn't bound to words and only became visible in shared gestures of visual exchange. The blackboard exercises usually started with one specific question, such as "How to know when you're finished?" or "How to make good art?" followed by interventions from all participants: drawing, re-drawing, posing bodies, changing body postures, erasing, re-drawing, drawing, and so on. Using the blackboard felt like working on an endless temporal palimpsest that captured the constant erasing and over-writing of what had been written by others beforehand, while it was simultaneously captured by a video camera and then turned into a time-lapse video.

On May 18 the group proposed to start with the question "Who is 'Carla'?" On the one hand I understood this proposal as a (maybe even necessary) continuation of the discussion we had a week before about my art-making process. On the other hand, however, it felt unsettling to answer this rather personal question collectively. Although we agreed that "Carla" was not me but an abstract type of artist we included in our typology, "Carla" still felt close to me. It could just as well have been me who was being written on that blackboard.

Throughout the exercise, I felt tense and stressed. I watched every move the others made while trying to make sure that my handwriting was all over the answer. I was relentlessly trying to control the process. No matter what the others did, I tried to clean it up, to frame it quickly or to steer it in a different direction I felt more in control of. I produced symmetries where there were none. I mimicked strokes and signs to create patterns that gave me the feeling of controlling the chaos of chalk. The process felt similar to what I usually experience every night between 11 and 1 a.m. That is a compulsion to arrange things symmetrically to mirror me in the neat arrangement. Creating geometries and forms within a clean structure reassures me of myself, or rather tricks me into thinking I am how I like things to be. It's also how I produce art. Although I spent some years excessively painting, I am by no means a painter. I added some colors on the canvas before starting to clean up. I created forms, shapes, and patterns I understood and liked through cleaning, framing, and the occasional redirection of paint. It's also how I navigate myself in the world of academia. I observe and look out for patterns, symmetries, and analogies. If I am lucky, I see relationships and coherences no one has consciously noticed before me.

This compulsion to look out for patterns only ends in exhaustion, and just like every night, exhaustion also hit me in front of the blackboard. After an hour or so I started to feel too used up to constantly catch up with the eight hands of Wiktoria Furrer, Nastasia Louveau, Maria Ordóñez, and Artur Żmijewski. Reluctantly, I stepped back and let the chaos unfold before my eyes only to realize that the answer to the question "Who is 'Carla'?" is deeply interrelated with this tension between keeping control and losing it. The way I—artist type "Carla"—produce art can be located at this very tipping point. I know that this is a very self-centered way of reflecting on the workshops, but this now leads me to the core of what the workshops taught me about art-making. Pausing and then observing the blackboard, allowing things to emerge and disappear without my own conscious doing, made me aware of how art can wash things to the surface you already know with your body but not yet with your brain. The collective exercises became a way of asking the blackboard questions and allowing our bodies to answer them, only to understand it later.

After I processed the impact the session had on me, I revisited my art studio. I looked at what I have put on paper over the last four or five years, up to a hundred painted portraits, every single one of them depicting a figure either without a face or without any head at all. Early on I titled these painted portraits *Sans Visage*, merely out of necessity, because people frequently asked me why there was never any facial expression when I paint. I never really thought about this question, just as I never questioned why I suddenly felt this urgency to paint all of these portraits. I would shrug my shoulders, explaining that somehow I was suddenly drawn to painting, and that for me the portraits don't need a face nor head. The portraits already contained everything I saw in a person. However, it took me some time to realize that it's as simple as that; that the paintings show what my eyes always knew but my brain didn't recognize yet: that I just don't see faces—prosopagnosia—that I don't ever think a face looks the same as the day or a minute before, not even mine. I usually don't recognize my own face nor my parent's faces. I don't read people's faces because I don't see them, and I don't paint portraits with faces because everything I need to know about a person's mood, I see in the way the person moves and gestures. So that's what I paint. All of this I captured on canvas again and again, but it took me four years and Artur's workshops to see it. Since that day in my art studio, I haven't picked up a brush because now I wonder what the point is in reproducing something you're already aware of. It seemed only right to move on. I now fully dived into analogue filmmaking, wondering what else there is I am not yet aware of.

Getting blackfaced

My third and final critical moment during the workshops surrounds the one analogue photograph of Żmijewski and me in my apartment's backyard (see fig. 131 on pp. 142–143). It's the same photograph Wiktoria Furrer mentions in her reflection on p. 178, and that she links back to a photograph taken in the context of colonialism by Otto Haeckel in 1912. The photograph was my response to the individual exercise #8, called Face Painting, which Artur proposed towards the workshops' end.

The task was to paint our faces with black and white paint and take self-portraits of us wearing this face paint or photograph others doing so. As a photographic device, Żmijewski lent us his Voigtländer, a camera constructed and subsequently used throughout the early 20th century. As per Żmijewski, the exercise was inspired by ritualistic body painting by Australian Aborigines. As a starting point, he showed us two photographs he titled "people in masks—photographs from the early 20th century" (see fig. 122–123 on pp. 136–137).

For obvious reasons, the Face Painting exercise was the one exercise that unsettled me the most. As a film scholar focusing on the notion of format and how formats convey socio-cultural relationships within the real space, I was well aware that capturing face masks with a German Voigtländer from around 1920 would eventually lead to photographs that remember, and to a certain degree re-enact, colonial violence. I was aware that painting my face black and white meant I would copy a ritual of applying face paint that was unfamiliar to me and my cultural background and mimicked other culture's traditions. I could also anticipate that composing the image, pressing the shutter, developing the negatives, and subsequently looking at the developed images would become a series of gestures that would inevitably repeat violent gestures stemming from colonialist practices. It didn't help that Żmijewski framed the exercise as something playful—as a game that would allow us to express ourselves safely. If anything at all, Żmijewski's way of casually framing blackfacing as something innocent made me even more cautious than before. I felt like this might well be the tipping point of the workshops; a moment I thought of as crucial for Żmijewski's way of inviting participants to act out gestures that would eventually unfold into mirror societies deep-rooted, past yet present entanglements with anti-Semitism, ableism or—as in this case—racism and colonial trauma.

For some reason I missed the first session—one of the only sessions I missed throughout the entire duration of the workshops. I did have a solid reason why I couldn't participate that day. Yet I also knew that I needed more time to thoroughly think about Żmijewski's proposal. I used the additional time to check the images Żmijewski handed out as inspiration. One I found out to be a photograph by German missionary priest and anthropologist Martin Gusinde, who between 1919 and 1924 documented the then already vanishing tribe of the Selk'nam on the Tierra Del Fuego archipelago at the southern tip of South America. Since the mid-20th century, the Selk'nam tribe has been considered to be extinct due to genocide. For days I felt like it would be better to skip this exercise. In the meantime, however, I saw how playfully the other participants were approaching the task. I studied the images they made. Some of them were unintentionally uncanny, to say the least. They were defined by an uneven and clearly uncontrolled way of capturing light; the light hovering around the image, almost ghost-like; the emulsion marked at times by almost violent scratches with fingerprints and dust all over the image. I was struck by how much tension the images captured, not just the tension between being a playful exercise and a re-enactment of violent gestures of appropriation, but also a tension between past actions and present legacy, cross-generational violence and trauma, and between a colonial

gaze and fetishization of the Other. Tensions that act upon us as a society, that are difficult to pin down but somehow became strikingly visible through these very images.

Honestly, these are images you neither want to take nor to see. They are complicated. They challenge you personally, and although they might be the result of a playful exercise, they are not fun anymore because they make you uncertain of your role within complex relationships you never wanted to be a part of in the first place. But that probably doesn't mean that we shouldn't take them or look at them. We might be a part of it, whether we want it or not, and making this entanglement visible at least comes with the potential of recognizing, remembering, and envisioning alternatives.

So, eventually, I invited Żmijewski and Ordóñez to my place. I let Żmijewski paint my face and take photographs of me. I asked Ordóñez if she could document this process with a second camera. The resulting image entailed more meaning than I initially anticipated—Furrer certainly did a better reading of it than I could ever do. However, this photograph and the way I shot it also encapsulates my internal struggles with artistically approaching emotionally heavy, socially problematic topics. Yes, I completed exercise #8, Face Mask. At the very least I didn't avoid it just to protect myself and to play safe. But out of fear of getting cancelled for blackfacing, I let Żmijewski take the full responsibility and staged him as the one in charge while staging myself as an object, as the result of a power dynamic beyond my control. I briefly hesitated to do so but then went along with it, thinking that no one would be surprised anyway to see Żmijewski in such a problematic role. Also, he probably wouldn't mind anyway because he always puts art first. He's badass and seemingly never cares what it costs him to make a point. So what started as a fear of being used by Żmijewski turned into me using him in order to make my point.

There are some things I learned from this situation, about art-making, but also about myself, and this is how I want to conclude my reflection. If there's really a point to make, someone has to do it, and this someone might as well be me and me alone. Next time Żmijewski won't be there for me to dodge the bullet. So if I want to point to where it gets complicated, I cannot be afraid of taking responsibility. I cannot shelter myself from criticism I anticipate before I even start. I learned that an impactful image might be more important than how people perceive my role as the one who made the image. I learned that quitting, avoiding, or playing safe, is utterly meaningless. I was able to fear, approach, and confront these challenging moments within the safe environment of a workshop. Initiating, enabling, protecting, and guiding this process is what I think is part of the answer to the question *How to Teach Art?*

Nastasia Louveau

The Polarizing Pole

My encounter with Artur Żmijewski and the other participants of *How to Teach Art?* and our intensive work and exchange have had a lasting impact on me, workwise as well personally, which are deeply intertwined fields. Even during the months when the workshops were happening I was very passionate about our discussions, our hands-on experiments, our personal bonds that were emerging; our discussions and the questions we pursued within flooded the conversations I had outside of the workshops. Today, three years later, I see how I keep returning to some questions, topics, and figures (for example to the "characters" of the categorization of artists as a cartoony leitmotif) and how some others have crystallized through time and experience into some kind of lived answers—to roughly quote Rilke, as I am following his advice to the young poet.

When I first heard about the workshops, it was the title that caught my attention: *How to Teach Art*. How to teach art? How to teach art! In the academic setting of Slavic and Cultural Studies, of Literary and Gender Studies, which was both my intellectual home as a PhD student and the way I sustained my adult life as a teaching assistant, this combination of words and worlds was mind-blowing. This question, the fields it combined, and the setting it was happening in coincided with an understanding I had and a direction I wanted to take—as a self-taught visual artist, as a researcher, as a teacher/learner, I felt this was a major opportunity I could learn from immensely, no matter what that would be—in my daily endeavor to let creativity flow, to make space everywhere for creative practice, and within the context of Academia and of scientific research for forms that are associative, practical, manual, creative (for example drawing portraits as a note-taking practice).

I did not know Artur Żmijewski, I was not acquainted with his work. I had merely heard or read his name because my supervisor and some colleagues had been engaging with his work and published a book with him the year before (*Kunst als Alibi*, 2017, in the same collection as the present publication). So he had been present in a floating way, and if I had a vague notion of who he was, I had absolutely no idea about his accomplishments, his relative fame, his topics, and media of predilection; I just knew he had been invited to Zurich by a team of professors whose work I respected a lot, and he was proposing this amazing-sounding series of workshops. I went into this experiment with a huge curiosity and the wish to play and learn. And I feel this is very much what I got from it: playful and deep learning, through continuity and slow pace, through vulnerable and sincere exchange, through community and the bonds that grew out of it.

Even though I signed up for it mainly because of my interest in teaching and in consolidating my training in didactics and pedagogy, I remember that while we were at it, immersed in the exercises and the discussion, I had the feeling that we had lost sight of the question of how to teach art and that we were mainly dealing with expe-

riencing the creative process, how "to control it" (which was Żmijewski's wording and interest) and reflect on it. I did not understand the extent to which what we were doing was related to the main question. This is actually quite typical of any classroom situation: the learning subjects are so engrossed in the particular (moment, subject, question) that they cannot see the bigger picture. It is also quite typical of an outstanding and specific teaching situation, one based on the principle of first-hand experience and process reflection in order to gain insight.

Process reflection happened during our discussions within and without the workshops. Wiktoria Furrer mentions the moments of crisis most of the regular participants experienced over the course of it. The reflection I want to share has to do with these moments. I experienced Artur Żmijewski, the facilitator, as a polarizing force. His succinct, deadpan, understating style simply can't leave listeners indifferent. I was reminded of a Berlin club called Klub polskich nieudaczników, the Club of Polish Losers—I felt there was something utterly "Polish" about his style and humor. His short statements and terse insights ask for a response, their curtness creates a space in which one wonders: Is this humor? Why do I feel so uncomfortable? Can I agree with this person? Is he making me an accomplice of something? Is he crazy? or funny? or very cunning?

Then, getting to know some of his work, i.e. getting to know Artur Żmijewski the artist, I realized it garnered very similar reactions from me and others. I wondered if this could be yet another type of artist? It could be a new type we haven't discussed yet—I would like to call them in a very serious, tongue-in-cheek way "The Polarizing Pole." This is a type that speaks and acts in a minimalistic way and whose statements and acts demand of you an immediate response, a reaction, to position yourself. For you to react, they absolutely need the minimalism and shrewdness of short sharp statements, there is no smooth social cushion, there is no flower lining, there is no guiding you—so that your answer can be the rawest and perhaps the "truest." This calls for crises, I think. This is what triggers crisis moments.

Of Artur Żmijewski the person, the social being equipped with social skills, we all got glimpses and impressions. Żmijewski's partner Zofia Waślicka and their baby son Adam would also participate on some days or simply be around us while we were discussing. We shared meals, we had some moments that felt funny and light and daily, but in this span of a few months and within this workshop context I felt it was virtually impossible to differentiate between roles and functions (between the private/public, seeing Artur as an artist/facilitator/person and myself or each of us as a workshop participant, a "guinea pig" in Żmijewski's newest piece, an artist in their own right, or simply as a person). Also because there was never a strict lab situation where we were just one or the other; we incorporated and impersonated all these roles simultaneously.

Looking back, the one "crisis" I had with the Polarizing Pole that probably stayed in the mind of everyone was my refusal to adhere to his obsession with trauma, death, history of violence, etc. This is easy to remember, as it is something I voiced and also playfully staged in one of my responses to his exercises. The Study of the Pregnant

Body I submitted instead of a Study of the Old Human Body was my way of dealing with the feeling of discomfort I felt in Żmijewski's universe, and also a way to take back agency and propose something else, to choose my own path for my own learning process. I had a childish pleasure in scheming it with my pregnant friend, and in filming her with the 16-mm camera, seizing the opportunity of this exercise to portray something very fleeting: not only the state of pregnancy just a few weeks before giving birth, but also our bond of friendship in this very moment, the distance and closeness between me and you, the tenderness of the sun watching us. Now, considering all the polarized intensity contained in this response to the original exercise, this 16-mm film might actually—*ex negativo*—be very affirming of Żmijewski's "obsession," while at the same time conveying something else about my sensitivity.

The inner dialogue prompted by the Polarizing Pole went further. While working on the edition of this book I recognized another moment of crisis that was much more far-reaching and that took much more time to concretize into a definite shape: the deep "Artur crisis" I had crystallized around the question of ambition—see under the "(Subjective) Summary" of May 28 in the discussion section. I participated in the theory-development discussions and opened up about my own artistic practice/process, trying to relate to Żmijewski's typology of artists. I said, "I have no ambition." I wrote, positioning myself in the network of relationships and ideas we were weaving in our discussions,

> I don't think I've ever striven to be a badass artist. No socially highly relevant, cutting-edge issues, no ambition to take center stage, no pressure (because that would mean a lot of pressure.) Still, it is no "decorative art" that I'm making, no "design"—I see it mostly as a way to communicate and to trigger emotions and discourse, as it combines both in a pictural assemblage.

His answer came as surprise. It was simple: I was too well off, too sedated by a comfortable Swiss (=Western) environment where I didn't need to fight for my survival or that of people around me. I felt hurt by Artur Żmijewski's unapologetic gaze not only at my statement but also at the position I was speaking from. I had made myself vulnerable, playing around with the tools we had developed together, and there I was, "naked", feeling unseen and plainly hurt. I wanted to be heard, saying, "Look, here are the formats and the shapes I take and work with, following pleasure and curiosity and care."

Today I still stand by these words. I find my standpoint sweet and beautiful. And I also see how my position has shifted since the workshops. It is so subtle a change that I can contain my own contradictions without having to admit them. But containing contradictions and living them openly is one of the most self-caring experiences I have had. Today I would no longer say that I have no ambition. I still follow pleasure, curiosity, weave personal networks of care around me in which I can be, live, and work. But my work definitely took on "ambitious" shapes, less afraid of tackling politically relevant issues that I let myself be touched and transformed by. Following the questions we articulated towards the end of the workshops—"What's in the earth? What's in the air?" and mainly, "What's in the body?"—my own unrelenting

research exposed itself: how to make space within oneself and within community for mourning and grief and healing? How to find that space of grieving already inscribed within one's body, within the living? One could perhaps call it: my own obsession ... Some of that current work is still unfolding and taking on very contrasted shapes:

(a) The musical project *Louvovitch* has developed over the past three years. It combines numerous activities and practices that are altogether new to me and that I delved into passionately: songwriting, composing, singing and playing instruments, performing on stage in front of audiences, creating stage designs, recording and producing songs, having a vinyl record pressed, screen-printing record sleeves, also giving songwriting workshops, etc. It is a project based on a growing repertoire of songs and revolving around the character of Louvovitch, an alter ego voicing grief in many languages, using their vulnerability on stage and the materiality of their voice to tap into bodily experience and pain and to move listeners in moments of community. This project has many collaborative aspects (technical, creative, performance-related, etc.) that all crystallize around the persona or the ego of the figure Louvovitch. There is a very healing and loving dimension of performing songs through this persona in and for a community. (See fig. 159–161 on pp. 168–169)

(b) The following work has a collaborative dimension too, and unlike Louvovitch "it [does] not belong to one author" (as Wiktoria Furrer states of the mode of collective thinking we experienced in the workshops, see p. 176). To further quote her words, the focus is "on what we produced and not on the demarcation of individual contributions," so I hope my telling the story of how it came to be from a first person perspective and my personal entanglement with it does not eclipse its utterly collective authorship. (See fig. 162 on p. 169)

Participating in the feminist protest movement Ni una menos in Zurich, I learned that even in a "well-off, comfortable society" such as Switzerland, the gender-based murders of women*, girls*, and also trans*, inter*, or genderqueer persons[14] are a reality, undeniable and unbearable. On average, femicides happen every other week in Switzerland. Together with two close partners and in a creative exchange with them, I started a work last winter that had been floating within me, swimming inside me waiting to find its shape. At first the three of us, later on with a growing group of accomplices, we created female* mourning figures (painted and cut-out on cardboard as some non-verbal demonstration signs). These figures were immediately given the name of *Klageweiber*, the mourners, as I related them to an archaic practice of loud mourning that I had experienced at burials in my grandmother's village in Central Serbia. They are colorful and show crass images of pain personified through cartoony body positions and facial expressions (black holes for the eyes, distorted mouths).[15] They take action by joining protest demonstrations and sit-ins, carried by a few supporters. We come for example to Ni-una-menos-Platz, formerly named Helvetiaplatz, in the middle of Zurich, on protest days; we lean against the mourner figures as if wearing oversized masks and the hybrids we thus create and impersonate occupy the public space. Sometimes the mourner figures accompany the protesters in silence; sometimes they cry and sob loudly and dishearteningly for very long minutes.

They draw the attention of passers-by to the femicides. They seemingly intimidate or irritate the police, who insistently repressed this non-violent protest movement during the winter months in the guise of Covid-19 prohibition of assembly. And they create a space within oneself and within public space for an unfathomable grief. The mourners transformed me. They also move many people who cross their path. They now seem to be living a life of their own, going their own path. Local journalists of the national newspapers *Tagesanzeiger* and *WOZ* noticed them; they have appeared in articles on femicides, on structural, gender-based violence, and on the political action led by feminist activists to bring about change. They also faced critique by a group of young People of Color who raised their own questions and articulated their own pain while encountering the mourners at a demonstration in June 2021. Some of these questions were: Are these figures with their pictural red, purple, green, yellow skins racialized? What do they have to do with us and with our own experience? Are we conscious of any appropriation? This encounter and this critique prompted a dialogue within me and with some other mourner accomplices that is still ongoing.

I see how all the topics we tackled, circled around, and named in the workshops were just as much ours as Żmijewski's. Even the topics we rejected with force, the ones we named and put into narrations, the ones we thought had been imposed by external eyes and minds: everything we said and did was our own participation and our very own projection onto the blank space Żmijewski and his practice offered. This practice—and perhaps this is what characterizes badass art practice—opened up a precious and unapologetic space for our questions and doubts and for dealing with them, also the ones we weren't ready to assume quite yet.

Maria Ordóñez

From the White Sheet to the Darkroom

I joined the workshops within the framework of my doctoral project about the ways a group of people in Colombia makes sense out of violence, absence, and loss through everyday gestures such as walking, cooking, fishing, and drawing. A collaborative art-based project I am still developing in the Department of Cultural Analysis at the University of Zurich, supervised by Prof. Eduardo De Oliveira (UZH) and Prof. Andrea Botero (Aalto). At the time I had spent just over a year in Switzerland in a new context: social, geographical, emotional, and work-related. I felt foreign and "other," just as much as my new context felt foreign and "other" to me. I was oscillating between *here* and *there*. Between the place I had left and my immediate context, between my previous practice and my new "academic" work, and in view of the hardships people I work with were facing in Colombia. My experience was defined by distance and interference: with my family and David, my partner at that time; with the place I come from and the people working with me, my friends, and with the challenge of holding bonds by phone—through the voice. The very nature of my work is to relate to people in the in-between space I inhabit, and to engage with the questions that drive my practice (of absence, violence, etc.).

During the first session of the workshops I felt the anticipation of expressing myself and sharing my work with new people, and especially with Artur Żmijewski. While I was at art school in Bogota I heard about him in the context of one of the courses on contemporary art. He was a prominent reference, and most of the debates on his work were concerned with the way he involved people and set work conditions. One of the dimensions of the debates involved the fact that he works with *victims of the Holocaust* and/or with people with body conditions such as maimed body parts and artificial limbs. Vulnerable bodies, as mentioned in the introduction of this book. When thinking about what constitutes my practice and personal experience, I am both a *vulnerable body* and *a victim*;[16] in the same way, those working with me are affected by different forms of violence in the context of the internal armed conflict in Colombia. A few times I have been noted as an "*artist* who works with *victims*." Well, my work is neither more nor less than this but a practice in which boundaries are no longer so easily drawn; a fine line between *me* as someone co-elaborating with people contesting what the idea of *victims* imposes and *me* as a person who exposes herself to and contests violence and categories the same way those I'm working with do, but in different circumstances. What I do can be better explained through the lens of vulner/ability—and here I am emphasizing the powerful dimension it has as the capacity to let yourself and others be transformed by creative processes. A practice tremendously touched and colored by the emotions and experiences of those involved in it and exposed to it.

In what follows I invite you to dive into my experience focused on what silence, distance, involvement, and movement meant as conditions of my participation in the workshops.

Did I forget my script (or my role)?
In the first session Żmijewski pointed out the involvement and participation the workshops would demand. Some of us agreed in silence, others by curving their eyebrows, and still others by laughing. He invited us to introduce ourselves and talk about our work and disciplines. When the moment of talking about my work came, I hesitated to voice anything at all. When it comes to talking about my practice, no matter the context, language, and the number of people present, I tend to become wordless, facing difficulties to communicate. We were around thirteen people seated in a semicircle—artists, curators, and doctoral researchers—as I introduced myself. That day I was one of the last ones to speak—if not the last one. I said my name, where I came from, and what my research project was about. Inevitably, I described myself the same way I had been doing for the last four years, following a narrative heavily burdened by the way my geographical and cultural backgrounds affect how I am perceived by others, and by the way I perform myself and my practice here (in Switzerland) as a foreigner, and there (in Colombia) as a latent person. Someone who is momentarily, remotely, and interruptedly present. Like what Nastasia Louveau mentioned in one of our conversations about this text, *the in-between I inhabit.*

As a researcher, my work is part of a larger exploration I began long ago whereby I understood art as a way of approaching what I do not understand and/or what I cannot name, but also as a common language when co-elaborating with others. Art as a way of encounter and dialogue when spoken and written words constrain the possibility of involvement.

Before ending the session Żmijewski asked us for our opinion on meeting twice per week and developing individual exercises/responses to the questions he would give us. The time frame and format were set: an intensive three-month workshop that would end up in a collective exhibition.

Participating meant the acceptance of and commitment to exchanges based on steady confrontation. To me it sounded like the way most social relationships are established; nothing to feel scared about and everything to run away from. Anyway, I decided to stay—little did I know how intense it would be and how hard to leave behind. Before the session ended most of us agreed to participate in a closed Facebook group as a parallel way to continue and archive our discussion. One of us stated she preferred not to have a profile on this social network since she did not feel comfortable with it. Żmijewski replied that it was the platform he preferred to communicate and share information on the workshops. There was no more space for debate or an alternative to it. I accepted the task of creating and administering the group on Facebook.

The Theory Development Sheet: a blank space

For the next session Żmijewski brought charcoal pencils, color oil pastels, and a big fine roll of paper we taped to the floor. All in white, the taped paper looked like an unusual white carpet. He planned to use it as the surface to develop a visual discussion on the different forms and typologies of artists. Despite the invitation to collectively intervene, he was the only one who dared to write and draw on it during the first encounters. It took days for anyone but him to step on it.

While other participants were actively and loudly debating, I followed the dialogues as if muted—offstage. My way of answering came by observing and walking around the Theory Development Sheet. Savant, Samara, the Alchemist, the Lifestyle Researcher, the Artisan, the Shaman. Instead of joining the discussion and proposing new categories, I got stuck in all that they seem to exclude. I had an inner debate on where to find myself among them, and if not, where outside their boundaries—once more, offstage. *Why am I hesitant to get framed or frame others into categories? What does this long and winding line among categories mean to me? How to escape categories?*

In silence, I reflected on my past, the way I was taught in the art school and the way I formulate and answer questions through creative practices. At this point the idea of silence, time, and distance as conditions of my work—my (dis)abilities?—deeply resonated in my mind. Instead of elucidating a problem/need/lack of space to express myself, my response made the media of my approach audible and visible. To be more exact, a set of conditions and gestures based on the way I relate to space by walking, waiting, and observing. This discussion not only demanded a theoretical background and a set of language skills but also the confidence to let emotions come out through the movement and uneasiness of my body. In 2018, while on one of my *fieldwork* stays in Colombia, I was invited to a round table among graduates at the university where I studied. Among the questions of the meeting were: where are the graduated students now and what are they doing? The answers were not at all conclusive. By the time I was invited to this discussion, I was, as I am right now, wondering how to weave in my *creative practice* and work as an academic researcher. Language creates categories and labels, and since moving to another place, I had become a foreigner in a double sense. Here, due to my migratory status and the way I feel different, and there, by turning the place I used to live in into a merely functional category of Western/hegemonic academic research, namely the *field site*.

As the visual discussions within the workshops evolved, connections, layers of time, concepts, personal experiences and other traces became more visible and overlapped. "The palimpsest," as Wiktoria Furrer called it, included textures, strokes, materials, colors, keywords, new questions, and silences—in the form of dark-colored stains or blurred words. Some of these words, concepts, and questions deeply resonated with me: *privilege, geographical, geopolitical, how to activate something, how to mediate it, how to let things (dis)appear.* A constellation of lots of connections to be

made. Even this number came up as an entry point: 267922789155785,6597855. Or was it a codified answer?

While choosing the photos for this book, I went through the fragments of the palimpsest, revisiting them from a new angle, a different scale and pace. My process was simple: I selected some images, and I played with their contrast and color settings, leading hidden layers to re-appear. In the making of this book, which has been a hard, long-lasting creative and systematic process, I was at long last able to re-encounter the Theory Development Sheet—not white any more. Through this process I was confronted with a new perspective: I strongly felt what Louveau mentioned as *losing sight of the core question*, or how the passage of time allowed me to revisit our conversations, enabling new connections.

The darkroom
As a way of taking care of my emotional process, my response involved physically distancing myself from Żmijewski, some of the participants, and the paper itself. While following the discussion on the typology of artists, I wondered about my practice as a process in which other forms of language, not only verbal, are involved. Two years later I came across a new category for the list: the Silent Practitioner—and here I am doing what I said I did not like to do. This idea involves silence not merely as refraining from sound but as the space to let other ways of response and corporealities manifest and be heard. Probably as much an intention as it is a condition.

Within the blackboard conversations, the visual dialogue got a new angle by getting swapped from the floor onto the wall. A change of surface and format through which I could explore other gestures and forms of front-line participation. A voiceless but written experience centered on the resonance of our movements and the meeting of chalk and surface. This choreography involved other gestures: walking in front of the blackboard, using objects and extensions of ourselves as part of the response (chairs, stairs, and a plastic skeleton), drawing with wet sponges, and our bodies adding layers to the colored chalk forms beneath. On this black dry smooth surface, my body acted as a medium in a completely different way from before. Here, space and material defined a new setup, and time was not only the answer but a condition (Blackboard Conversation 05/11/2018, see pp. 102–107).

In some contexts I resort to silence as a requirement instead of the manifestation of my own vulnerability—this is not the same to say that I am silent only when vulnerable. I could only perform the Silent Practitioner due to the active conversation of others around me.

Paradoxically, in most of the scenarios my creative practice is deeply entangled with the way I make connections with others. Only now am I aware that more than being educated to communicate by means of creative practice, I was probably rather constrained by it, because of a socio-geographical background characterized by the urgency of other means of expression that involved the body in many dimensions

(not only verbal). A personal and methodological framework based on the commitment to those I am co-elaborating with that entails an active listening practice as the only possible form of being cared for, seen, and understood.

I propose the following list as the core conditions of my creative practice:

1. Time: an ethical framework which allows me to move and act at my own pace.
2. Space: a physical frame to transform and in which those involved are transformed. It is where the body moves and becomes a medium.
3. Silence: one of the forms of relating to whom I do not yet know and a way of exchange that evolves throughout time and space.

In 2020, during the first lockdown period of the Covid-19 pandemic, Carla Gabrí and I became closer by sharing our experiences remotely. In September she invited me to share her studio, and I immediately accepted. I was happy to share a workspace with her. Her invitation and generosity included sharing her newly acquired work equipment with me: the 16-mm Bolex camera her boyfriend gave her for her birthday, the enlarger handed over by her father, and other useful instruments. In this darkroom we experimented and stored equipment, ideas, material, and images. A lab in which we tried out different processes from papermaking, photo and film development, to the exploration of one of the questions of the workshops: what is in the body/air/earth?

Most of the work and material I keep stored in our studio responds to the intention to experiment with the effects of the passage of time. As the effects I feel in me after four years of distance. *Here*, I came to acknowledge my own corporal rhythm and the way my body is the medium of my work. A complex system enabled to receive more than to transmit, and driven by intuition as an element that conditions the way of performing as a *slow and silent practitioner.*

It is because of you, Carla, Nastasia, Wiktoria, and the others involved in this experiment, and the way I was confronted by Artur's somewhat careless radical pedagogy, that I was able to make one of my most relevant findings (and that will probably make all my time *here* worthwhile): non-safe environments are common grounds for me since that is where I was (cons)trained and through which I found art as a language and a form of response and resistance.

Endnotes

1 This article builds on a previous publication and contains some fragments and thoughts extracted from it. See Wiktoria Furrer, "Micro-pedagogies. How To Teach Art," in Wolfgang Brückle, Sabine Gebhard Fink (eds.), Artistic Art Education, no. 9 (Lucerne: Hochschule Luzern Design & Kunst 2019), pp. 74–79. How to Teach Art? is also an important part of my research for my doctoral thesis, "Micropedagogies in Art," where I develop the concept of micro-pedagogy. | **2** "We" refers to the group of participants. I have gained many insights from interviews with some of my fellow participants following the workshops in 2018, as well as conversations on many occasions. My position may not always correspond with their individual experiences. In highlighting specific episodes of the workshops I try to give some impressions of the various and different experiences, whereas it must be clear that they stem from my fragmentary and subjective position. | **3** See Artur Żmijewski's description in http://postmedium.art/how-to-teach-art-czesc-1-moskwa/, accessed January 2021. | **4** See the section "Extension of the Typology of the Artist—(Subjective) Summary," p. 49–50 in this book. | **5** Ibid. | **6** I have developed the notion of affective infrastructure in previous publications. See Wiktoria Furrer, "Micro-pedagogies. How To Teach Art," in Wolfgang Brückle, Sabine Gebhard Fink (eds.), Artistic Art Education, no. 9 (Lucerne: Hochschule Luzern Design & Kunst 2019), pp. 74–79; Wiktoria Furrer, Sebastian Dieterich, "Micropracticing the local, localizing micropractice," in Being There: Exploring the local through artistic research, Nordic Summer University 2018 anthology, pp. 75–88; and Wiktoria Furrer, Henke Silvia, "Mikropädagogische Sprünge im Kontext ästhetischer Bildung", in Zur Zeit. Kunstpädagogische Forschung in der Schweiz, 2019 (16), https://sfkp.ch/artikel/16_mikropadago-gische-sprunge-im-kontext-asthetischer-bildung. | **7** Compare this section with the more detailed "Collective Mind," in Wiktoria Furrer. "Micro-pedagogies. How To Teach Art," in Wolfgang Brückle, Sabine Gebhard Fink (eds.), Artistic Art Education, no. 9 (Lucerne: Hochschule Luzern Design & Kunst 2019), pp. 70–76. | **8** See Paweł Szejnach, "On Kowalnia Workshop to the rest of the world," in Grzegorz Kowalski, Karol Sienkiewicz (eds.), Kowalnia 1985–2015 (Katowice: Wydawnictwo ASP 2015), pp. 505–527; Karol Sienkiewicz (ed.), Warianty. Pracownia Kowalskiego 2006/2007 (Warsaw 2007); as well as my description, Wiktoria Furrer, Silvia Henke, "Mikropädagogische Sprünge im Kontext ästhetischer Bildung," in Zur Zeit. Kunstpädagogische Forschung in der Schweiz, 2019 (16), https://sfkp.ch/artikel/16_mikropadagogische-sprunge-im-kontext-asthetischer-bildung. | **9** This quote is said to be from Hollywood film producer Sam Goldwyn. | **10** This project was possible thanks to the kind cooperation of the residents of the Alterszentrum and the support of Laurent Y. J. Schönherr from the Alterszentrum Kluspark. | **11** Information about the exhibition is to be found here: https://www.100ways.uzh.ch/en/about.html | **12** See David Summers, Real Spaces: World Art History and the Rise of Western Modernism (London, New York: Phaidon Press 2003). | **13** Sandra Frimmel, Fabienne Liptay, Dorota Sajewska, Sylvia Sasse, "Handeln ohne literarische Ambitionen. Ein Vorwort," in Sandra Frimmel, Liptay Fabienne, Dorota Sajewska, Sylvia Sasse (eds.), Artur Żmijewksi. Kunst als Alibi (Zurich: Diaphanes 2017), pp. 7–26. | **14** The asterisk here signifies woman as a social construct, and it is also a space meant to include trans*, non-binary*, genderqueer*, inter* people who do not necessarily identify with the terms woman/female. | **15** Writing this I am reminded of the antique marble statue of Laocoön grieving for his dead sons, and the space this figure occupies within Euro-centrist, white, male-dominated art history; the Klageweiber crying for their sisters and daughters seem like a multiple, cheap, subversive mirror of this reminiscence. | **16** A complex legal category given to those persons or communities affected by human rights violations in the internal armed conflict in Colombia (occurred after January 1, 1985): homicide, forced disappearance, displacement, rape, and other crimes against sexual integrity, kidnapping, land dispossession, anti-personnel mines, and other illicit methods of warfare, attacks against the civilian population. This legal recognition is needed to achieve measures of material and symbolic reparation. To date more than 9,000,000 people have been recognized as victims in Colombia.

Index of Images and Photographic Credits

If not otherwise indicated, the images are copyright of the How to Teach Art collective consisting of: Wiktoria Furrer, Carla Gabrí, Ekaterina Kurilova-Markarjan, Nastasia Louveau, Maria Ordóñez, Anja Nora Schulthess, Dimitrina Sevova, Nika Timashkova, Valentina Zingg, Artur Żmijewski.
This concerns mostly film and video stills from the collective exercises, blackboard conversations and photographs of the theory development sheet.

Fig. 1 Gusinde, Martin, Trois Esprits Shoort subalternes, Cérémonie du Hain, rite selk'nam, 1923. © Martin Gusinde / Anthropos Institute / Atelier EXB. | Fig. 2 Kurtilova-Markarjan, Ekaterina, Face-mask, Voigtländer camera, 2018. | Fig. 3 How to teach art collective, Theory Development Sheet, 2018. | Fig. 4 How to teach art collective, film still from the Blackboard discussion "Who is 'Carla'?", 2018. | Fig. 5 Gabrí, Carla, Camera Test, Voigtländer camera, 2018. | Fig. 6 Ordóñez, Maria, film stills from "Study of the Elderly Body," 16-mm Bolex camera, 2018. | Fig. 7 How to teach art collective, detail from the Theory Development Sheet, 2018. | Fig. 8 Londe, A., phototype Berthaud. © Javier Viver, Révélations. Iconographie de la Salpêtrière, Paris 1875–1918, RM Verlag, Barcelona, 2015. | Fig. 9 Photograph from the Jewish ghetto in Warsaw during Nazi occupation. © Sakowska, Ruta, Warszawskie getto W 45 rocznicę powstania 1943–1988, Interpress, Warsaw, 1988. | Fig. 10 Gabrí, Carla, Affirm the image over and over again until it finally starts to disappear, 2018. | Fig. 11 Ordóñez, Maria, Affirm the image, 2018. | Fig. 12 Ordóñez, Maria, Deny the image, 2018. | Fig. 13 Louveau, Nastasia, Affirm the image, 2018. | Fig. 14–15 Gabrí, Carla, Deny the image by turning the page, 2018. | Fig. 16 Zingg, Valentina, Deny the image by crumpling the image, 2018. | Fig. 17–18 How to teach art collective, details from the Theory Development Sheet, 2018. | Fig. 19 Ordóñez, Maria, De-compose/Re-compose body parts, 2018. | Fig. 20–21 Furrer, Wiktoria, De-compose/Re-compose body parts, 2018. | Fig. 22 Louveau, Nastasia, Drawn note, 2018. | Fig. 23 How to teach art collective, details from the Theory Development Sheet, 2018. | Fig. 24–25 Le Miroir, illustrated newspaper, 1917. © Le Miroir, entièrement illustré, Paris, several issues between 1914–1918. See online archive at Bibliothèque Nationale de France: https://gallica.bnf.fr | Fig. 26 Louveau, Nastasia, Enlarge selected image and convince viewers that you like it, acrylic and gouache on paper, 1.80 x 2.40 m, 2018. | Fig. 27 Ordóñez, Maria, Enlarge selected image, acrylic and gouache on paper, 1 x 1.5 m, 2018. | Fig. 28 Gabrí, Carla, Enlarge selected image by zooming-in, video stills, 2018. | Fig. 29 Louveau, Nastasia, Carla's process, drawn note, 2018. | Fig. 30–31, How to teach art collective, details from the Theory Development Sheet, 2018. | Fig. 32 Gabrí, Carla, Co-regulate/irregulate, video stills, 2018. | Fig. 33 How to teach art collective, detail from the Theory Development Sheet, 2018. | Fig. 34–35 Furrer, Wiktoria, Human geometry of the city, digital photographs, 2018. | Fig. 36 How to teach art collective, detail from the Theory Development Sheet, 2018. | Fig. 37–38 Zingg, Valentina, Study of the Hand, video stills, 2018. | Fig. 39 Ordóñez, Maria, Study of the Hand, video stills, 2018. | Fig. 40 Gabrí, Carla, Study of the Hand while competing in the Idiot task, video stills, 2018. | Fig. 41–43 Louveau, Nastasia, Documenting the collective discussions, Zenit camera, 2018. | Fig. 44–49 How to teach art collective, Collective visual discussion, video stills, 2018. | Fig. 50–59 How to teach art collective, Collective visual discussion with styrofoam horse, video stills, 2018. | Fig. 60–72 How to teach art collective, Collective painting, video stills, 2018. | Fig. 73–79 How to teach art collective, Blackboard conversation, video stills, 2018. | Fig. 80 How to teach art collective, Theory Development Sheet, 2018. | Fig. 81–101 How to teach art collective, Blackboard conversations, video stills, 2018. | Fig. 102–107 How to teach art collective, Collective visual discussion with wooden blocks, video stills, 2018. | Fig. 108 How to teach art collective, Collective visual discussion in situ, Exhibition 100 Ways of Thinking, Kunsthalle Zurich, 28.08.2018. | Fig. 109–111 Louveau, Nastasia, Documenting a face-mask exercise session, Zenit camera, 2018. | Fig. 112

How to teach art collective, detail from the Theory Development Sheet, 2018. | Fig. 113–114 Furrer, Wiktoria, Camera-test, Voigtländer camera, 2018. | Fig. 115 How to teach art collective, detail from the Theory Development Sheet, 2018. | Fig. 116–117 Furrer, Wiktoria, Architectural composition and self-portrait, digital photographs, 2018. | Fig. 118 Louveau, Nastasia, Architectural composition and self-portrait, Voigtländer camera, 2018. | Fig. 119 Gabrí, Carla, Architectural composition and self-portrait, Voigtländer camera, 2018. | Fig. 120 Louveau, Nastasia, Drawn note, 2018. | Fig. 121 How to teach art collective, detail from the Theory Development Sheet, 2018. | Fig. 122 Spencer, Walter Baldwin / Gillen, Francis James, Indigènes en tenue de corrobores, ca. 1910. © Musée du quai Branly – Jacques Chirac, Dist. RMN-Grand Palais / image musée du quai Branly – Jacques Chirac. | Fig. 123 Gusinde, Martin, Trois Esprits Shoort subalternes, Cérémonie du Hain, rite selk'nam, 1923. © Martin Gusinde / Anthropos Institute / Atelier EXB. | Fig. 124–125 Zingg, Valentina, Face-painting involving the grandmother, mixed media, 2018. | Fig. 126 Gabrí, Carla, Face-painting involving the father, Voigtländer camera, 2018. | Fig. 127 Sevova, Dimitrina, Face-mask, Voigtländer camera, 2018. | Fig. 128 Furrer, Wiktoria, Face-mask with ZHdK student Manoj Rajakumar, Voigtländer camera, 2018. | Fig. 129–130 Ordóñez, Maria, Face-mask with Artur, Voigtländer camera, 2018. | Fig. 131 Gabrí, Carla, Face-mask with Artur, Voigtländer camera, 2018. | Fig. 132 Louveau, Nastasia, Face-mask, Voigtländer camera, 2018. | Fig. 133–134 How to teach art collective, detail from the Theory Development Sheet, 2018. | Fig. 135–140 Gabrí, Carla, Study of the Human Body 16-mm Bolex camera, 2018. | Fig. 141–144 Zingg, Valentina, Study of the Human Body, 16-mm Bolex camera, 2018. | Fig. 145 Louveau, Nastasia, Study of the Human Body, 16-mm Bolex camera, 2018. | Fig. 146 How to teach art collective, detail from the Theory Development Sheet, 2018. | Fig. 147 Ordóñez, Maria, What's in the body? biopoetics, DIY microscopy, video stills, 2021. | Fig. 148–158 Gabrí, Carla, What's in the body? atopic skin, still photograph, developed by hand in vit. C, washing soda, and coffee, 2021. | Fig. 159–160 Louveau, Nastasia, Louvovitch vinyl record, 2021. | Fig. 161 Dancker, Christian, Louvovitch concert, Dietikon, 2020. © Christian Dancker. | Fig. 162 La Cuki, Ni Una Menos protest, Zurich, 2021. © La Cuki. | Fig. 163 How to teach art collective, detail from the Theory Development Sheet, 2018.

Authors

Wiktoria Furrer has a background in political science and cultural studies. In her dissertation "Micro-pedagogies in Art" supervised by Prof. Dr. Dorota Sajewska at the University of Zurich alongside with Prof. Dr. Dieter Mersch and Prof. Dr. Silvia Henke, she has developed the concept of "Micro-pedagogies", a fragile interplay of didactic, medial and material practices conducted by both artists and participants, teachers and students, and investigated the affective infrastructures in collaborative art practices. She is an associate of the doctoral program "Epistemologies of Aesthetic Practices" at the Collegium Helveticum in Zurich.

Carla Gabrí is a doctoral student at the Department of Film Studies at the University of Zurich, Switzerland, with a dissertation on textiles in the moving image 1970–2020. She is a member of the research project "Exhibiting Film: Challenges of Format" led by Prof. Fabienne Liptay and an associate of the doctoral program "Epistemologies of Aesthetic Practices." Her artistic practice oscillates between the media of film, painting, and object art with works series on the topics of prosopagnosia, obsolescence, and skin.

Nastasia Louveau explores dialogic processes and the notion of critical learning in her combined artistic, research, and teaching practices. A self-taught artist trained as a cultural researcher and educator, Nastasia deals with questions through a hands-on approach grounded in sharing, caring, and curiosity. Nastasia is working on a doctoral thesis on the couple as method within performance art in Eastern Europe (1950–1990) at the Slavic Studies and Gender Studies departments of the University of Zurich under the supervision of Prof. Sylvia Sasse.

Maria Ordóñez has developed her creative practice based on a participative, ethically-engaged approach. From an intersectional perspective, her audiovisual work responds to questions related to the ways daily gestures, rituals, places, and their materiality can enable alternative forms to overcome certain types of violence such as forced-disappearance of people in Colombia. Currently, Maria is working on her PhD project in the Department of Cultural Analysis at the University of Zurich, guided by Prof. Dr. Eduardo Jorge de Oliveira UZH) and Dr. Andrea Botero Cabrera (Aalto).

Artur Żmijewski is a visual artist, photographer, and filmmaker. From 1990–1995 he attended the Academy of Fine Arts in Warsaw at the Department of Sculpture guided by the Polish avant-garde artist Prof. Grzegorz Kowalski. Żmijewski is interested in art understood as a political and social research and as a reaction on current phenomena. He is also interested in creative process based on intuition, silence, and tough risk. He has often gone too far in his art—that's why his methods generated some controversies. A "dark legend" still accompanies the artist as a person who has a tendency to manipulate both realities: material and human. Żmijewski was head curator of the 7th Berlin Biennale in 2012. He was deeply touched by the practices of the activists from Occupy Museum which influenced him that time. He is currently exploring the "omnipresence of violence" in our daily life.